Introduction

I'm so excited to get the opportunity to make this book and share my passion for creative journaling with you!

The book is designed to help you to add simple creative elements to your journal pages, with over 1000 designs to guide and inspire you. Most pages begin with an exercise to get you started, so that you can learn how the shapes are formed and feel ready to move on to other designs. Over time, I hope you will grow in confidence and feel able to bring your own style and personality to your journal pages using the skills that you have learned from this book.

As someone who had never considered themself to be creative, I really wanted to design a book that could help others find their own creative path in an easy-to-follow and pleasurable way. You can start as simple as you like and build things up as you go. This book will show you ways to add more detail and colour – to really make your journal pages a unique reflection of your personality. Your journal will naturally record your progression and changing styles, with these creative elements helping to bring your pages to life.

Since I started sharing my journal pages online in 2016, I have made some wonderful connections with people from all around the world. I often get asked for tips and tutorials on getting started with creative journaling and lettering, which is why I am so happy to share this book with you. I hope you find it full of inspiration and that it motivates you to pick up a pen and start doodling, with no pressure or expectation.

Adding creative elements to my journal brings me so much joy and offers a welcome break from the frequent digital distractions around me. I hope this book helps you to enjoy the same experience and ultimately create journal pages that you are proud to look back on time and time again.

Helen

#journalwithpurpose

Journaling
with
Purpose

One of the great things about journaling is that there are absolutely no rules. You start with an empty notebook and, over time, you turn it into a special record of your life. There will be no other journal like it, as it will reflect your unique view on the world, your experiences and your own creative expression.

why journal?

A really useful starting point is to consider what the purpose of your journal is. This may well change over time, but having some key things that you document on a day-to-day basis can help you to make the most of the time you spend with your journal. It's important to consider what you are seeking from your journal, so that you can create the type of pages that will bring the most joy to your life.

There are lots of scientifically proven medical benefits to keeping a journal; for both your mental and even physical health. These benefits are really important to me and I feel my whole outlook on life has changed through writing and drawing in my journals every day.

One important area to consider is your journaling routine. When and how will you find the time to write and create in your journal? Like all habits, it can take a while to make it a consistent part of your daily life. Carving out a small chunk of time for yourself every day can really help with this, and you will also find that your creative skills improve more quickly with regular practice.

I find the evenings are a great time for me to reflect in my journal, as I don't have emails and telephone calls to deal with. We often sit in the living room as a family together and, while my daughter is focused on her home studies, I can take some time for myself without too many interruptions. Have a think about when you are most likely to have a little time to yourself and make a commitment to spending some of that time with your journal. Once it becomes part of your routine, you will find that it is something that you value and look forward to every day.

Being creative

Adding creative decoration to my journal is one of the elements I enjoy the most. Not only does it enable me to quickly relax my mind, I find that being able to add colour and doodles really brings my pages to life. It helps to set the tone for the month, reflects the colours in nature around me and quickly represents key moments in my life. Throughout this book, you will find over 1000 designs to help you to personalize your journal and document your own story in a creative and colourful way.

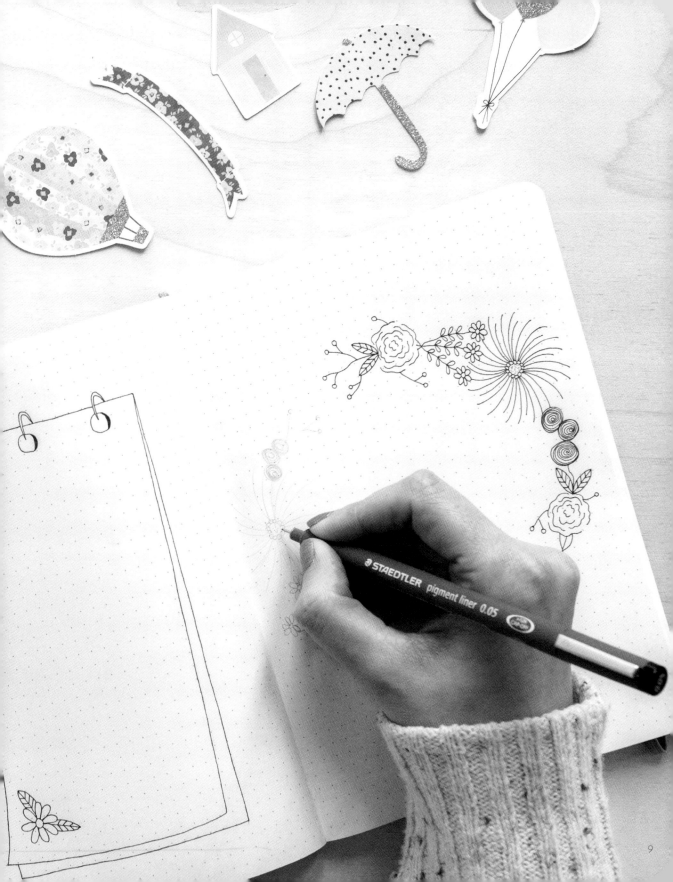

tools & materials

A good quality journal is something that is really important to me. I like to know that the paper can handle a wide range of inks and colour without showing through or bleeding onto the next page.

I use a variety of pens, pencils and paint in my journal, depending on the theme that I am creating. The items I always have close at hand are:

- Waterproof black pigment liner
- Pencil and eraser
- Brush pens for lettering and adding colour
- Fountain pen
- Washi tape
- Pastel coloured highlighters
- Variety of coloured pens and pencils
- Watercolour paints

You certainly don't need all of these supplies to get started; a notebook and pen will be absolutely fine. As you find your own style you can gradually add to your supplies and find products that you love to use.

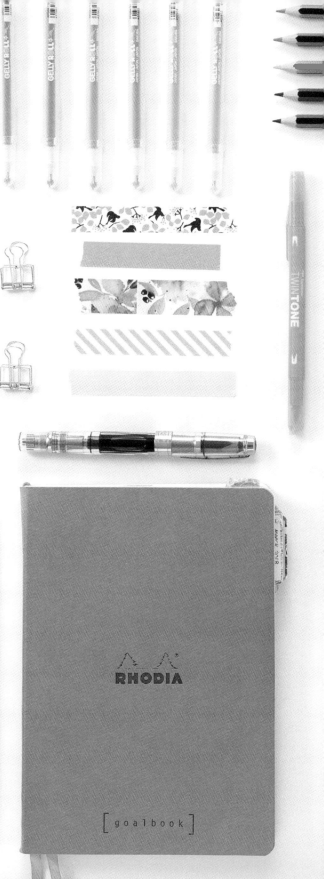

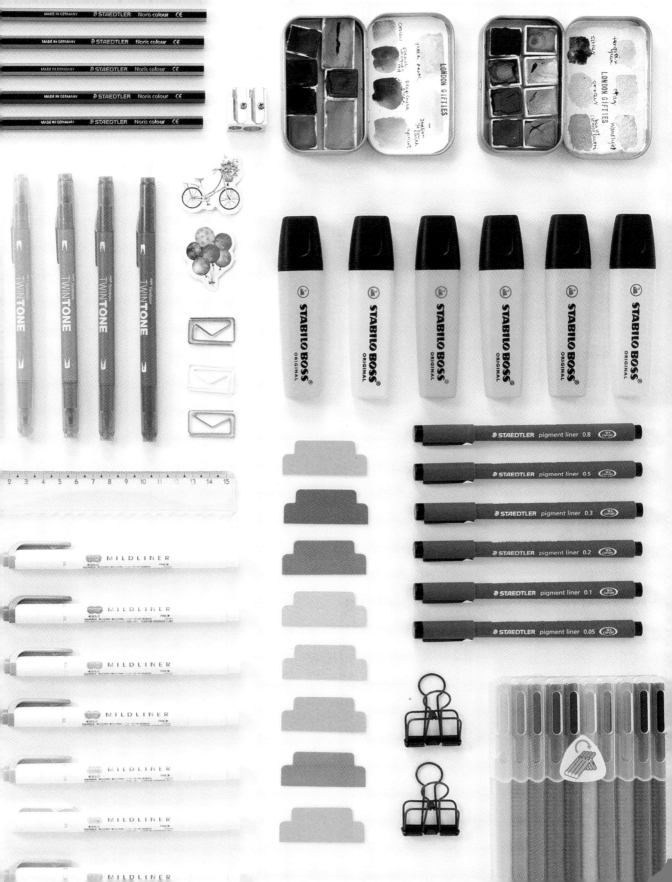

getting started

There are certain layouts that I feature in my journal every month, which are explained below. If you're unsure where to start, these can be used as a template for your first journal pages.

Month Opener

Each month feels like a new chapter in life to me. I choose to represent this in my journal with a spread welcoming the new month, which usually reflects the current season. It's a chance to pause, review the last month and put plans in place for the coming weeks.

Calendar

With each new month I find it useful to create a calendar where I can record any events, deadlines and things to remember. Alongside this I set myself some goals to work towards for the month. These could be related to work, home, creative projects or personal targets that are important to me.

I find this really helps to affirm my intentions for the month and enables me to easily set daily tasks that help me to move in the right direction. Every evening I quickly review my progress towards these goals and make any necessary adjustments to keep myself on track.

November

1	T	
2	F	
3	S	8pm table booked
4	S	
5	M	Office day
6	T	Lunch meeting
7	W	
8	T	Send newsletter
9	F	
10	S	Weekend away
11	S	
12	M	
13	T	9-11am Parcel due
14	W	
15	T	Send newsletter
16	F	Project deadline (1)
17	S	10am - haircut
18	S	
19	M	Office day
20	T	7pm - Cinema
21	W	
22	T	3pm - Train
23	F	11am - Meeting
24	S	
25	S	Birthday lunch
26	M	
27	T	Filming
28	W	
29	T	
30	F	

GOALS

- ☐ Finish project work - stage 1
- ☐ 30 min walk every day
- ☐ product research

TASKS

- ☐ book car into the garage
- ☐ work on newsletter template
- ☐ check train tickets
- ☐ arrange lunch for the meeting on 6th
- ☐ send out agendas

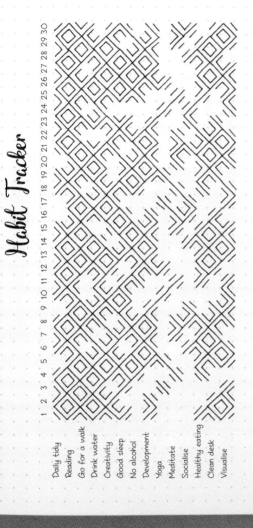

Habit Tracker

Once my goals are set, I think about the habits I need to regularly carry out to enable me to achieve these goals. These could include anything from daily personal development activities and exercising to practising new skills or spending time on something creative.

I use a habit tracker to record my chosen activities for the month. This is a simple system where you draw diagonal lines on each successful day in order to build up a pattern. You can design your own patterns and even use different colours for each line to make them look more interesting.

Take some time to think about positive habits that you would like to incorporate into your life and then enjoy checking them off every time you carry one out. I find even the simple activity of filling in my habit tracker every evening really motivates me to carry out as many of them as possible.

Gratitude

One of my favourite topics to document in my journal is all the things that I'm grateful for. It's a sure way to boost my mood and it helps to take my mind off anything that may be troubling me. Every evening, I take a few moments to reflect on my day and jot down at least a couple of things that make me happy. Occasionally it might be big things that I'm celebrating, but most often it's the little things that I'm most grateful for. Examples of this could be sunshine coming through the window, hearing the birds singing, reading a great book, an interesting conversation or sitting down with my family for a meal each evening. No matter how difficult a day might have been, I always find there is something to be grateful for.

Goals

It's been proven that writing down your goals on paper helps increase your commitment to working towards them. Goal setting is something I do at least once a year and then I break these down into monthly goals, to ensure that I have something tangible to focus on. You could simply write down your big goals, create a vision board, or doodle some images that reflect the goals you are working towards. I like to review my progress each month to make sure that I am on track, before writing down my goals and tasks for the month ahead.

Gratitude

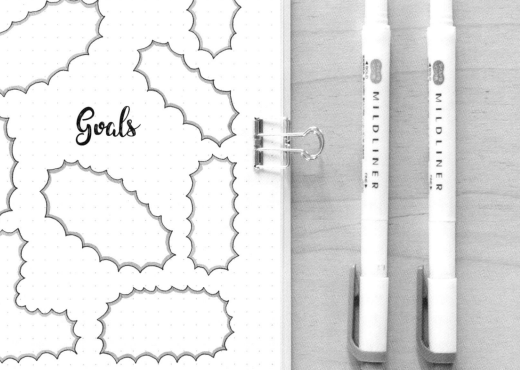

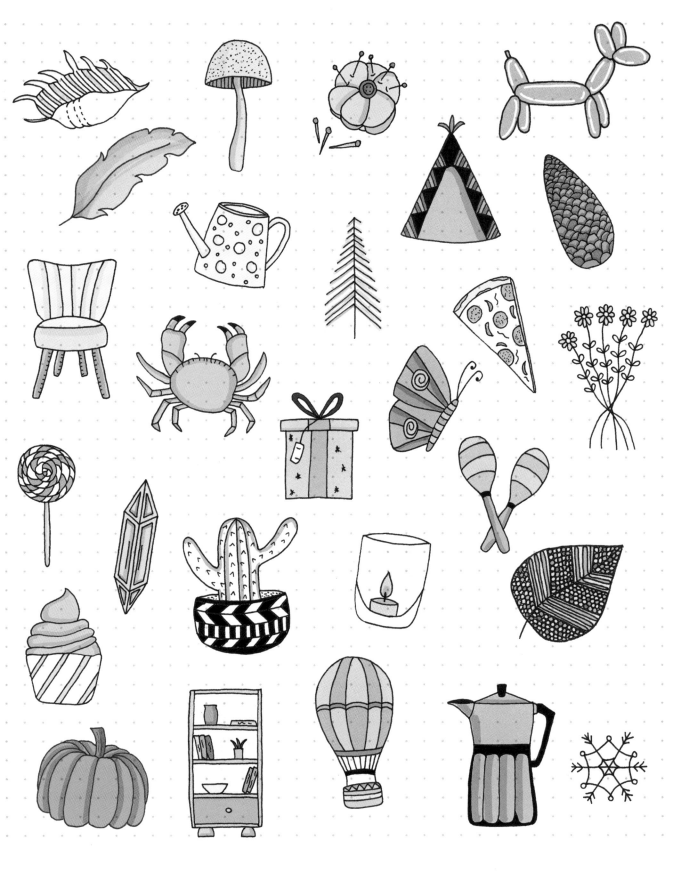

Design Library

BANNERS & SCROLLS

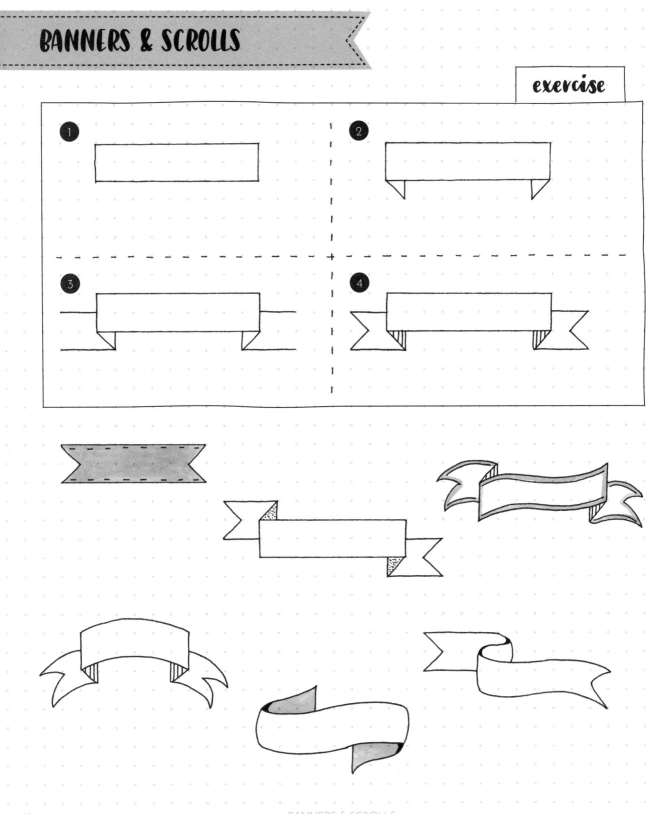

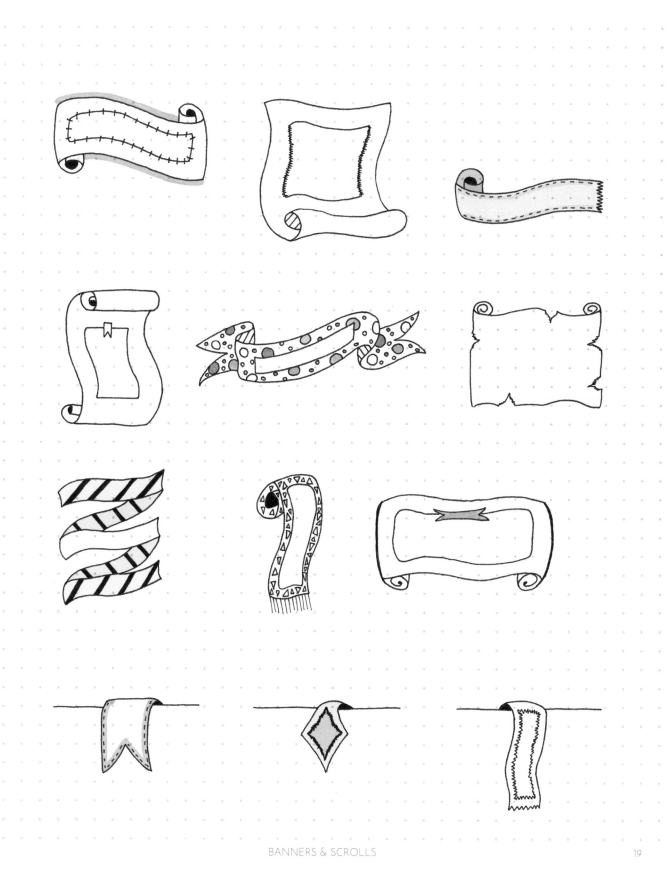

exercise

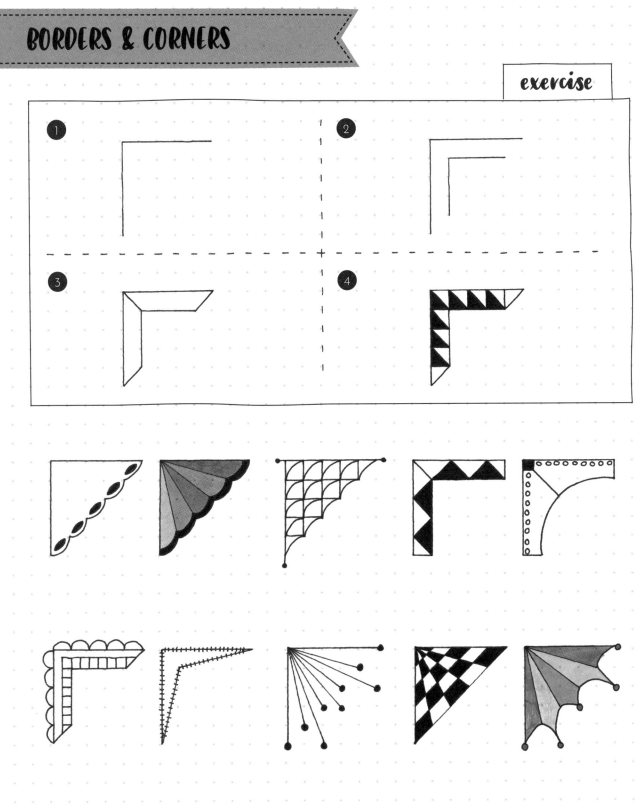

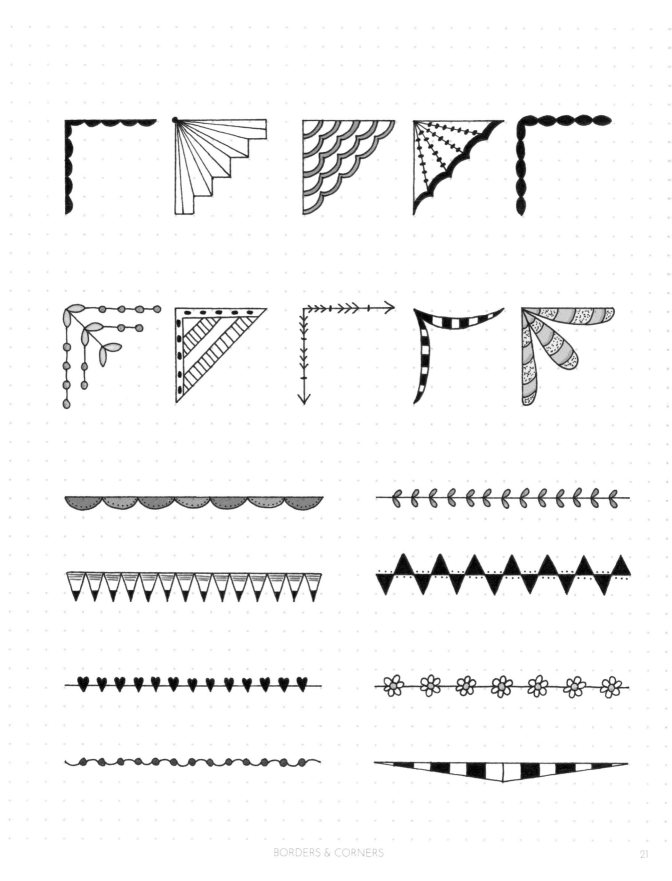

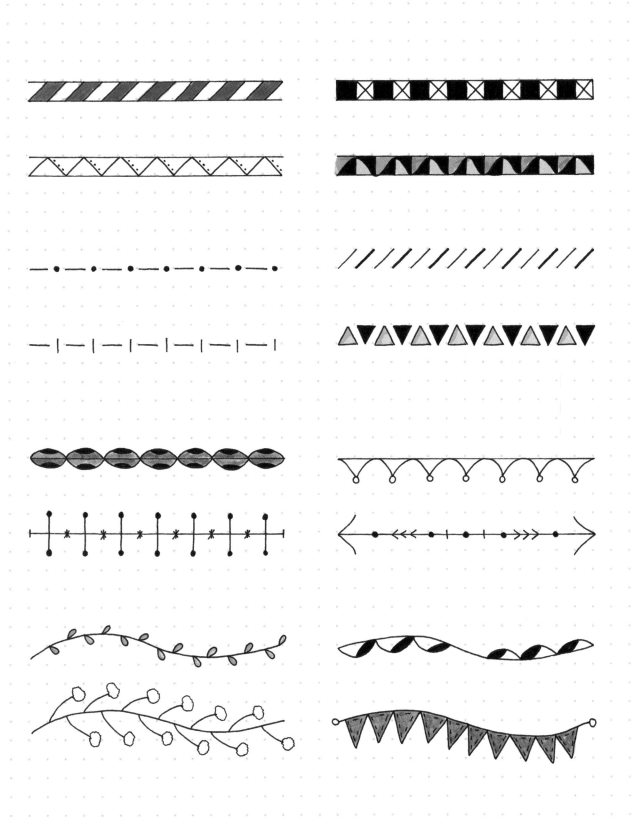

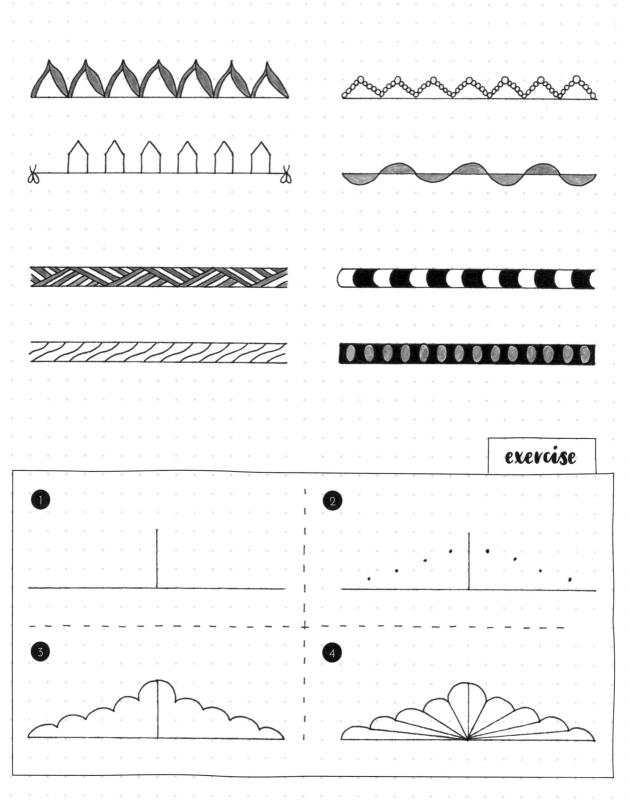

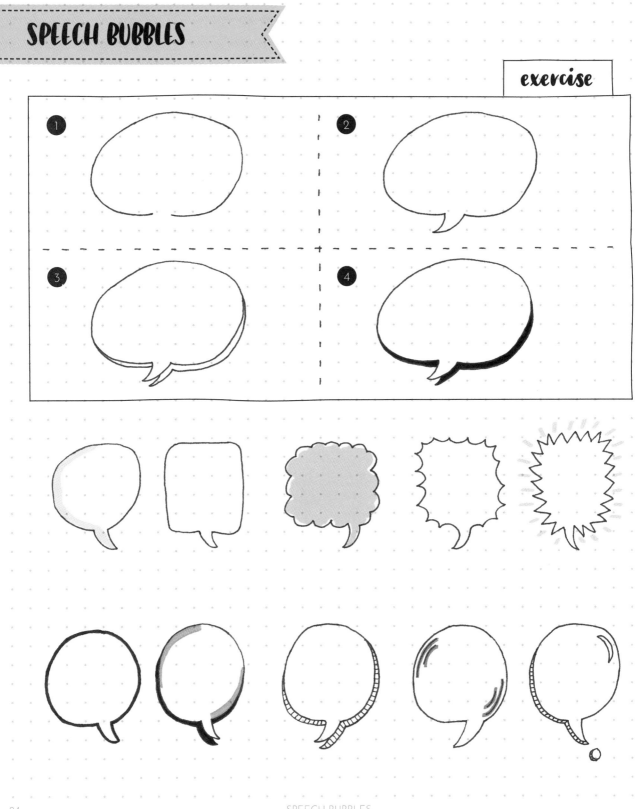

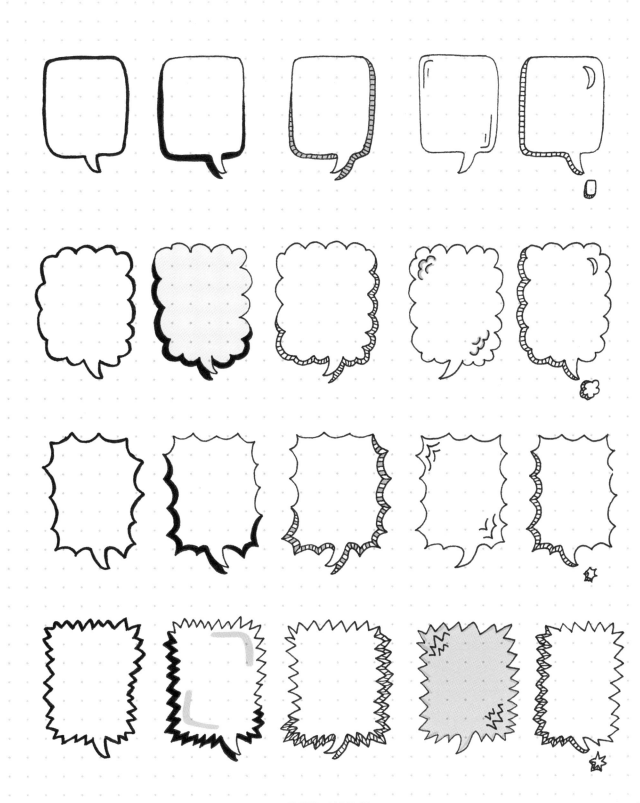

ARROWS

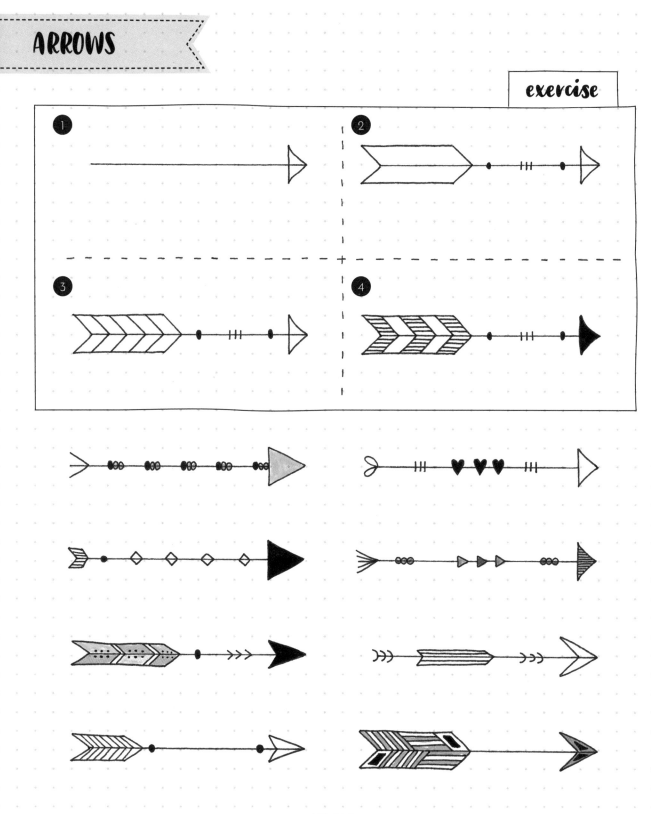

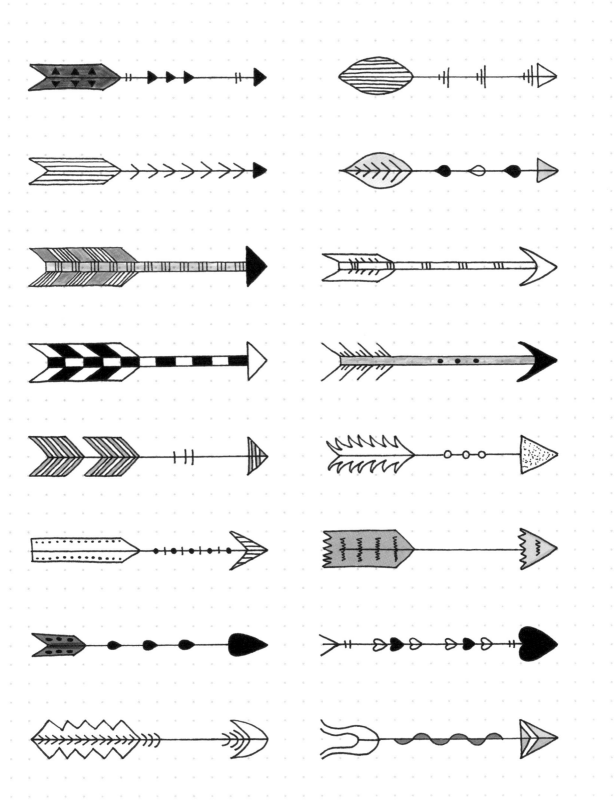

exercise

1

2

3

4

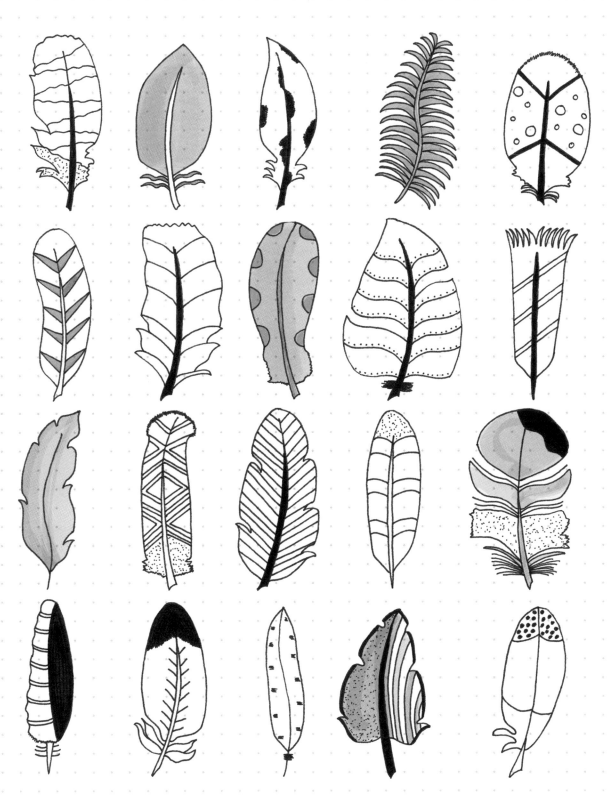

exercise

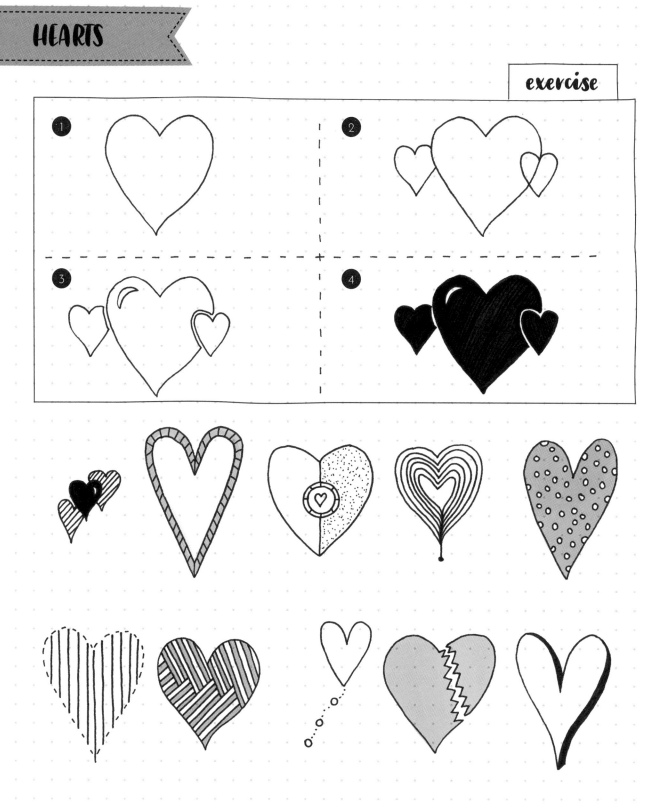

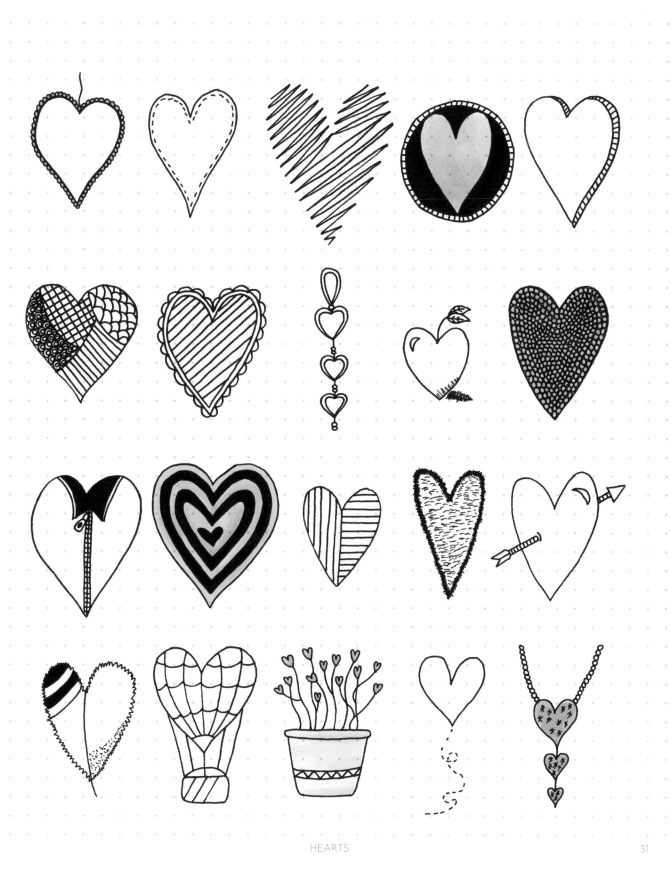

DREAM CATCHERS

exercise

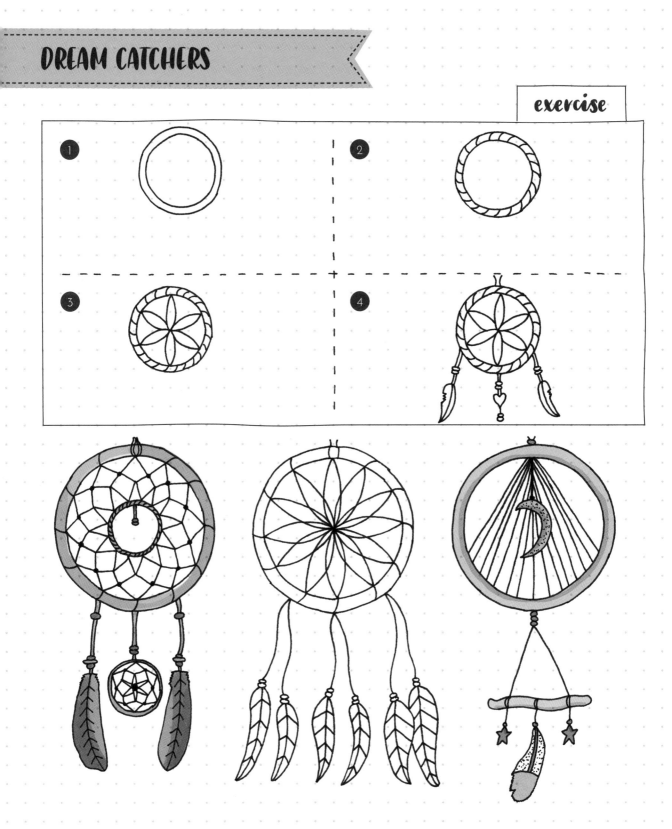

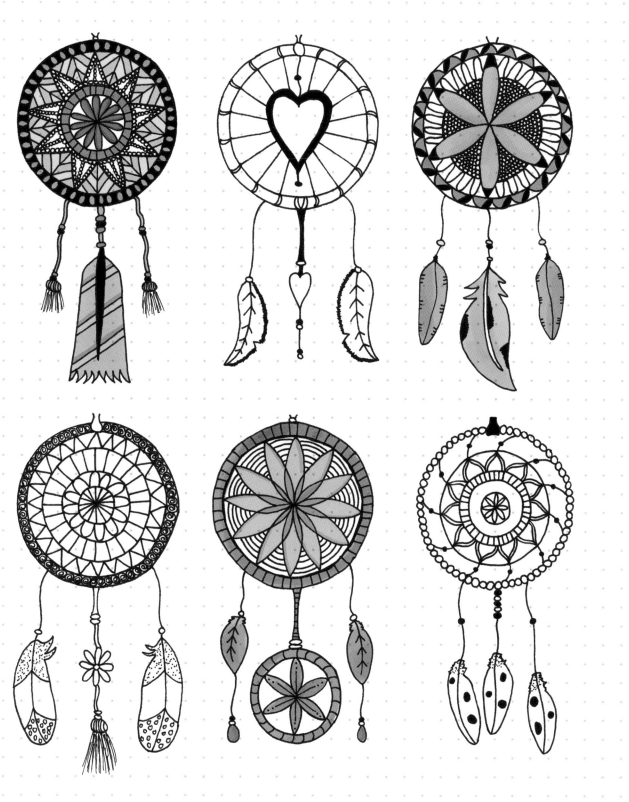

1

2

3

4

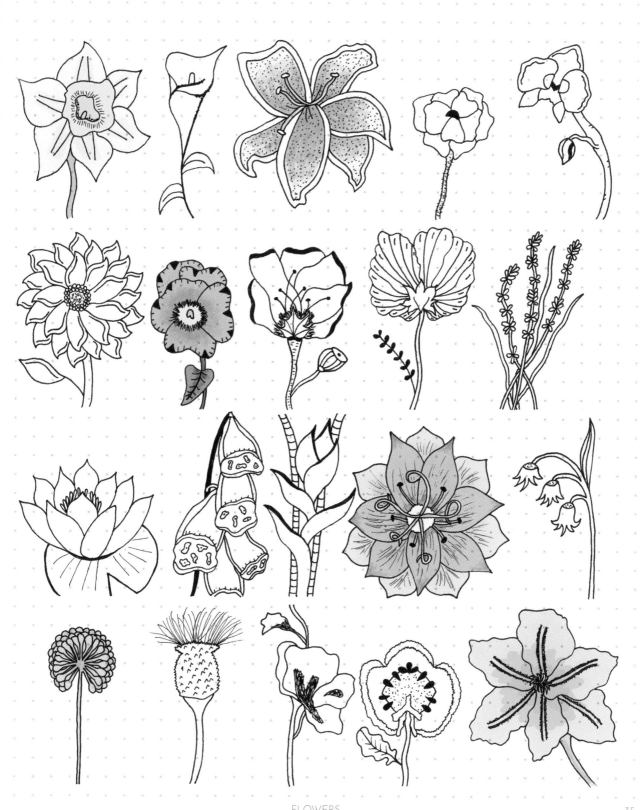

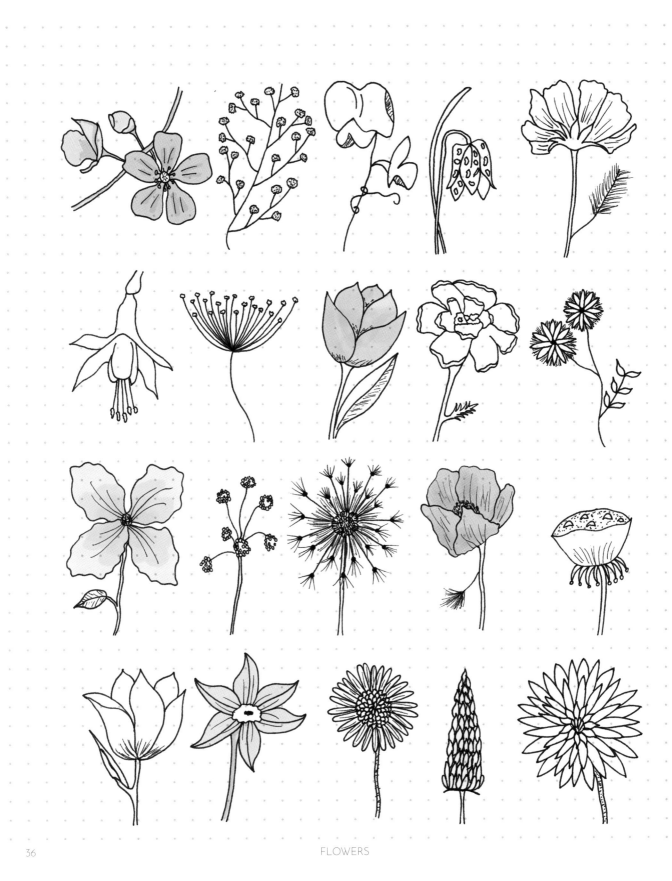

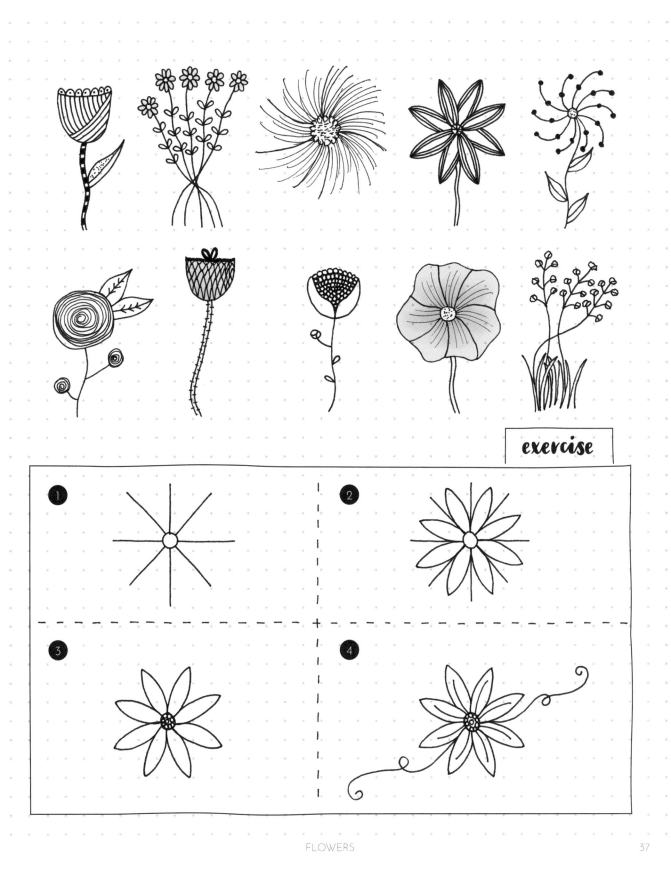

CACTI & POTTED PLANTS

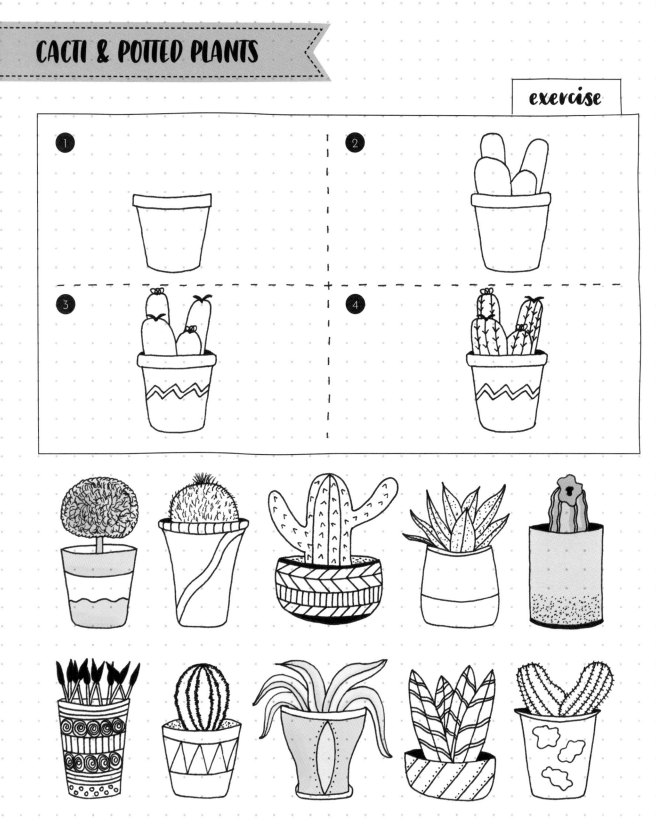

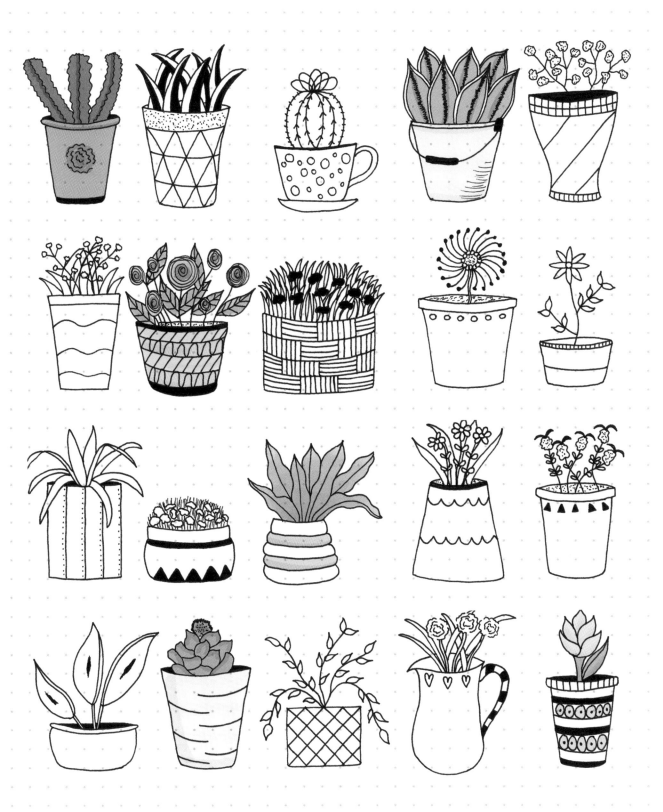

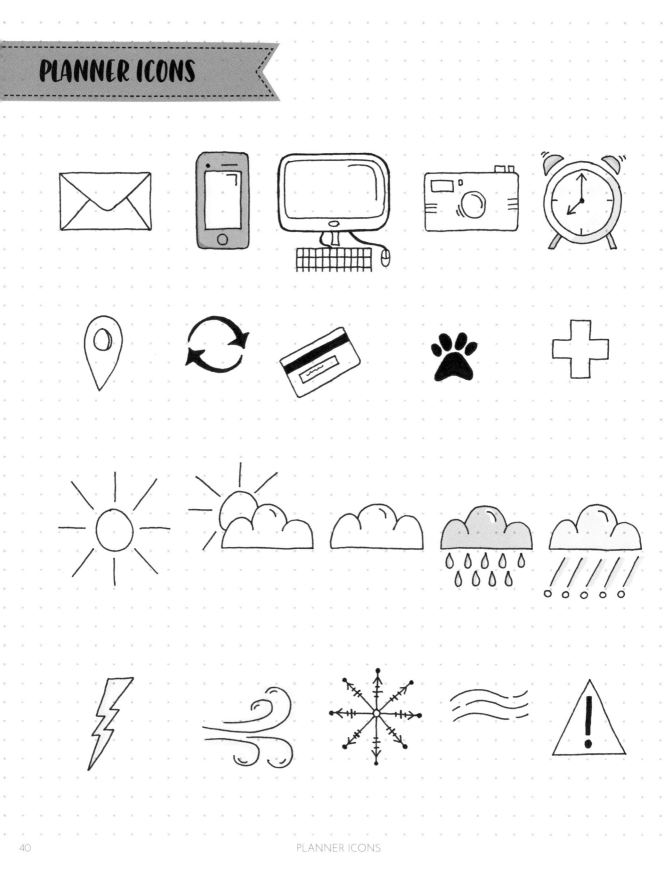

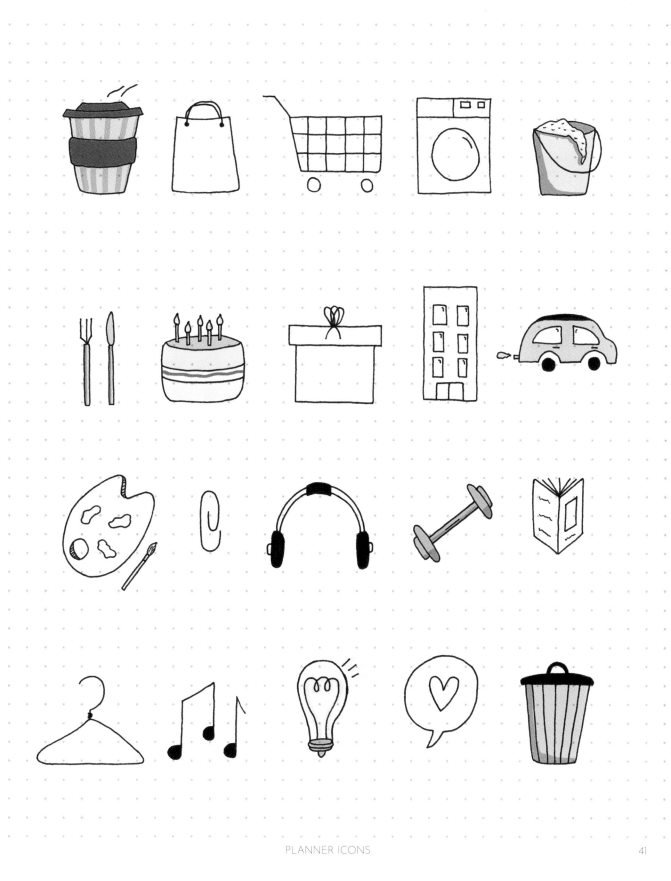

exercise

1

2

3

4

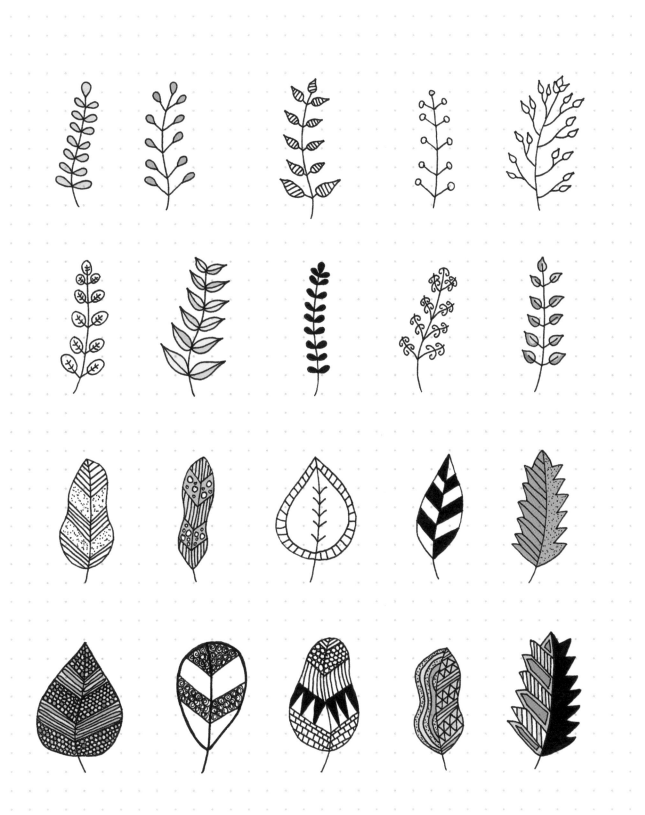

exercise

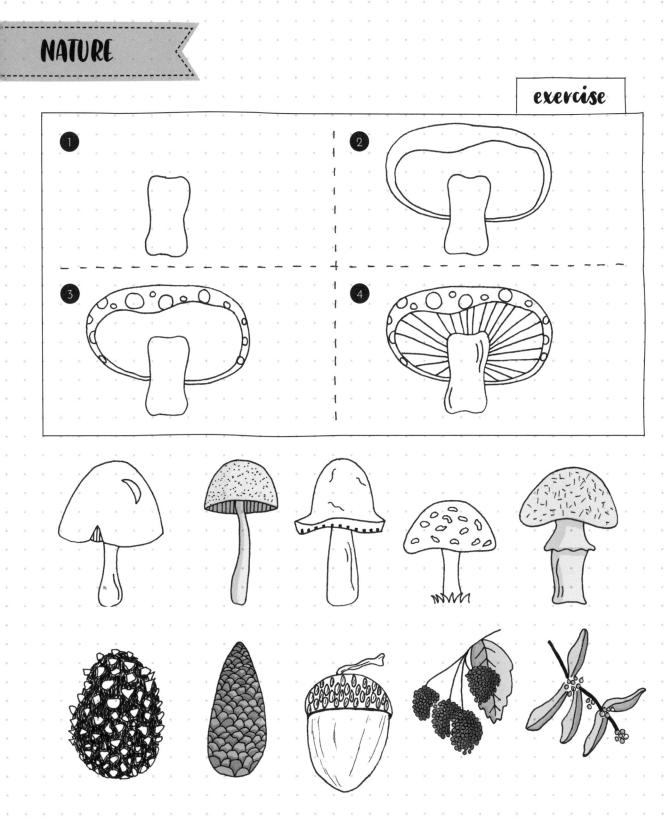

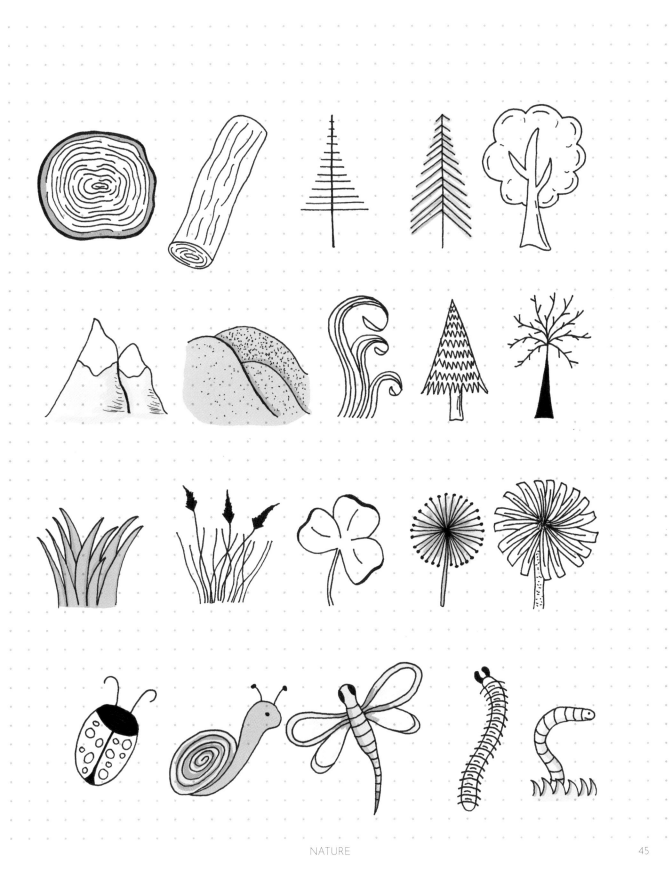

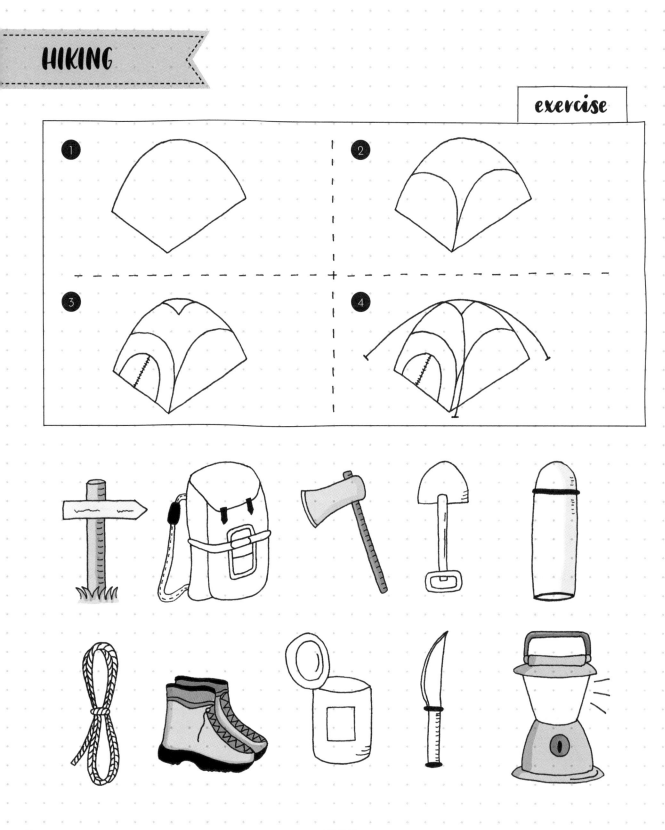

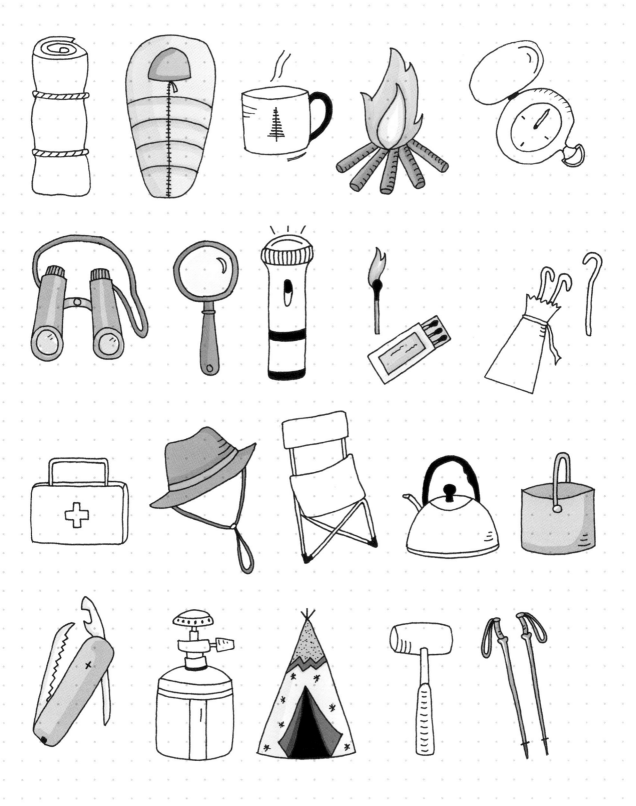

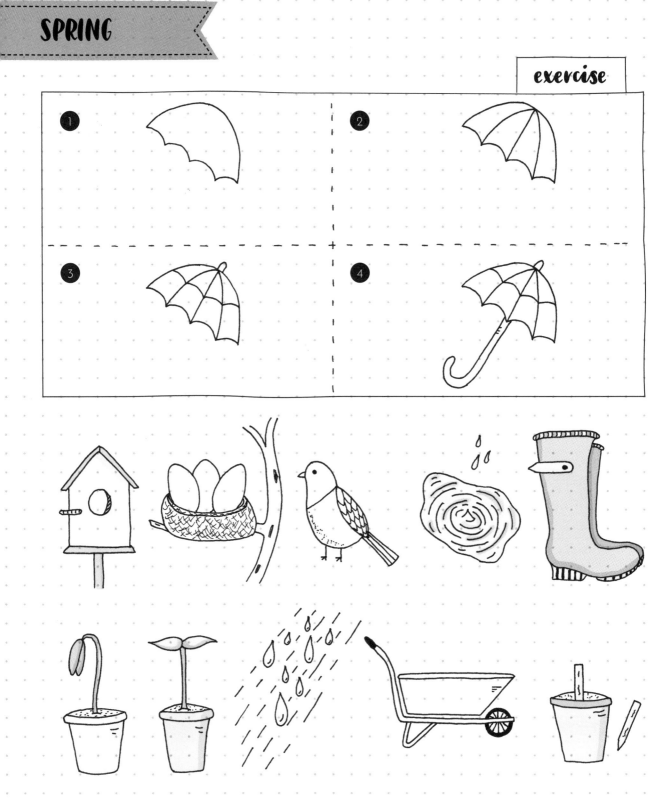

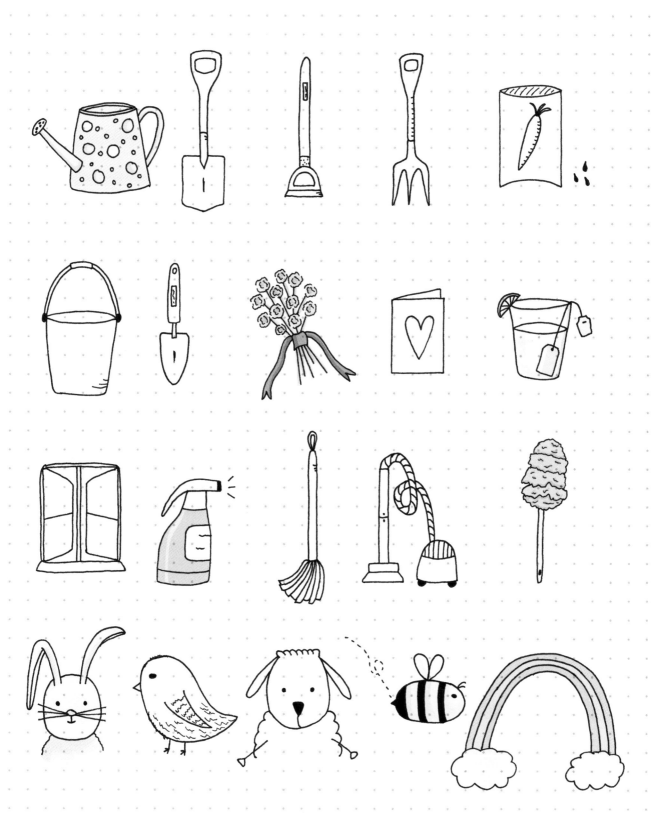

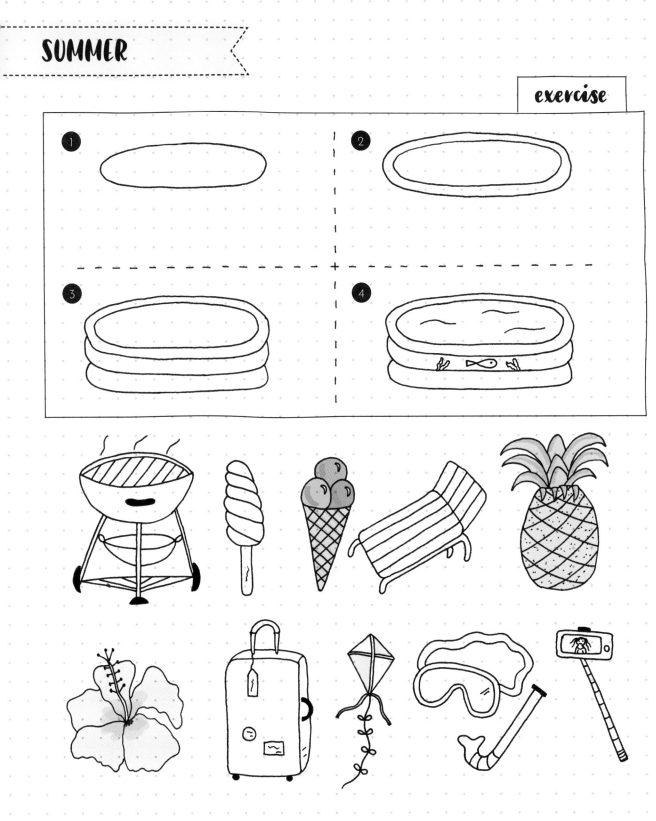

exercise

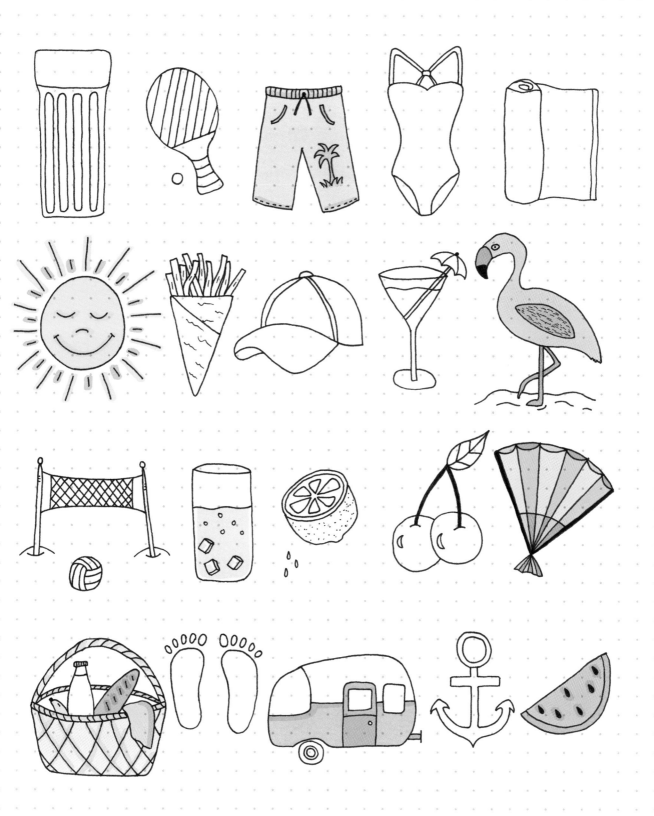

exercise

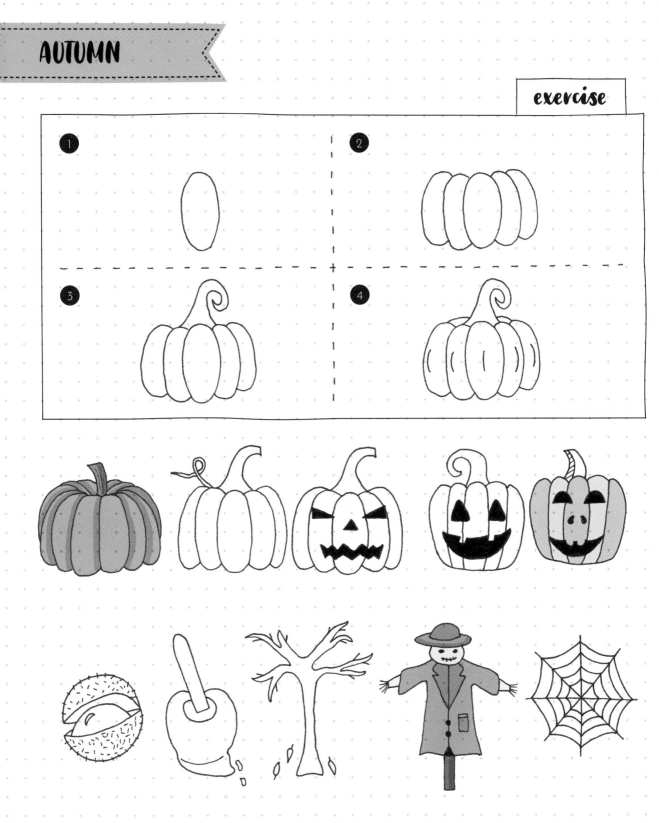

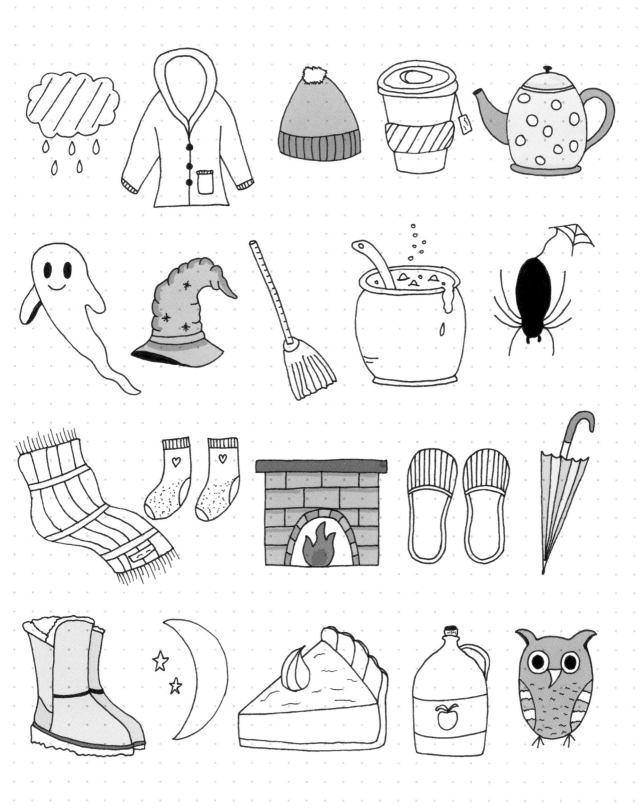

exercise

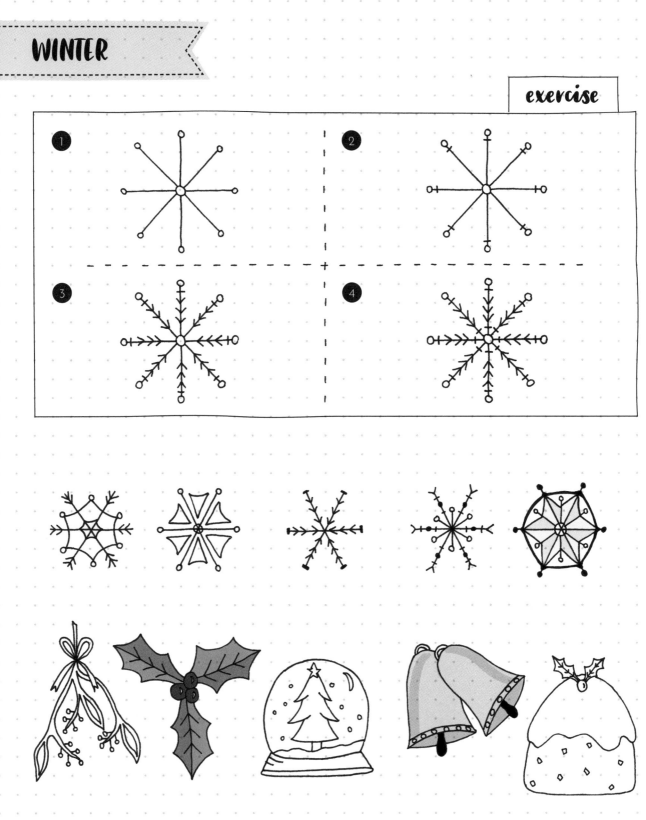

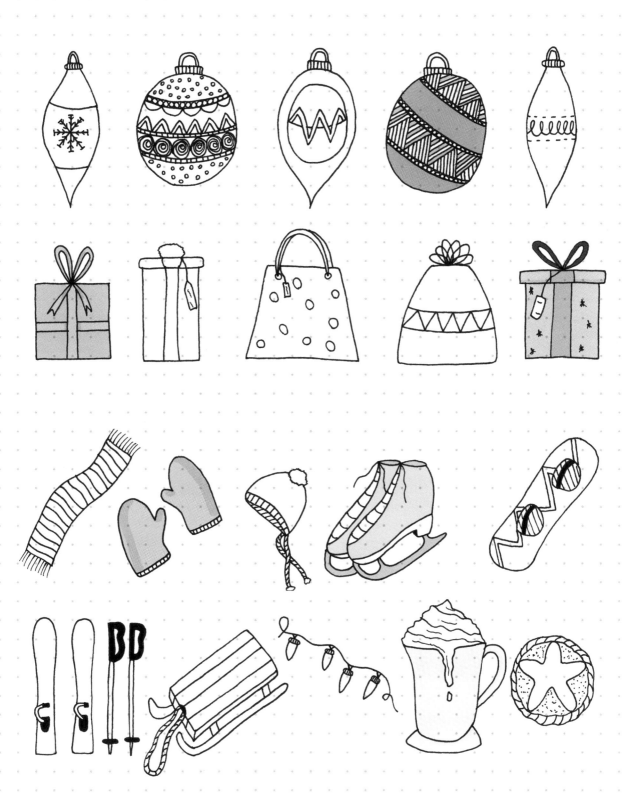

STATIONERY

1

2

3

4

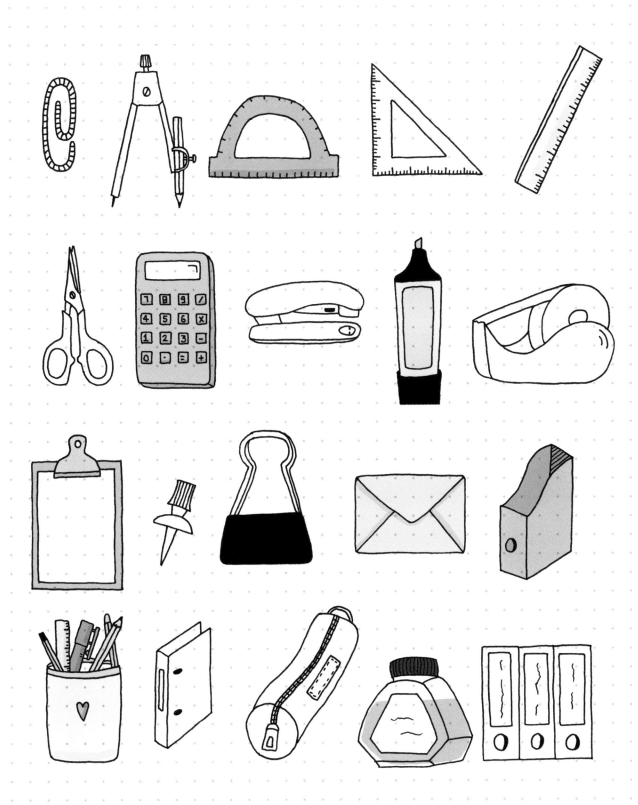

CANDLES

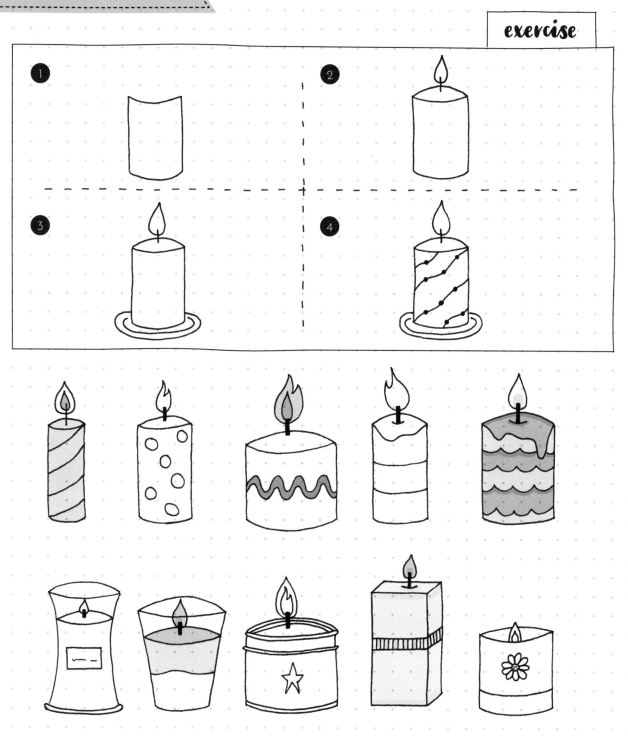

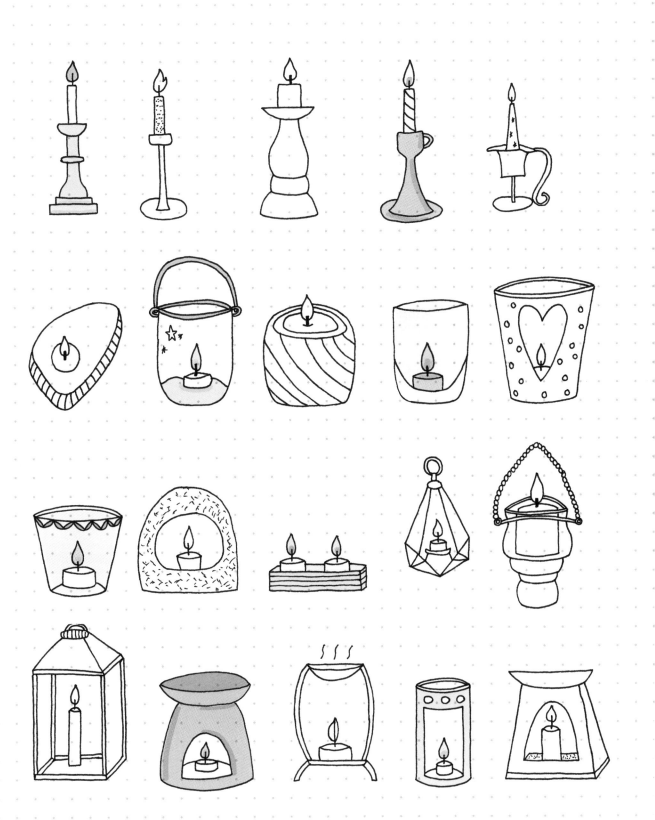

exercise

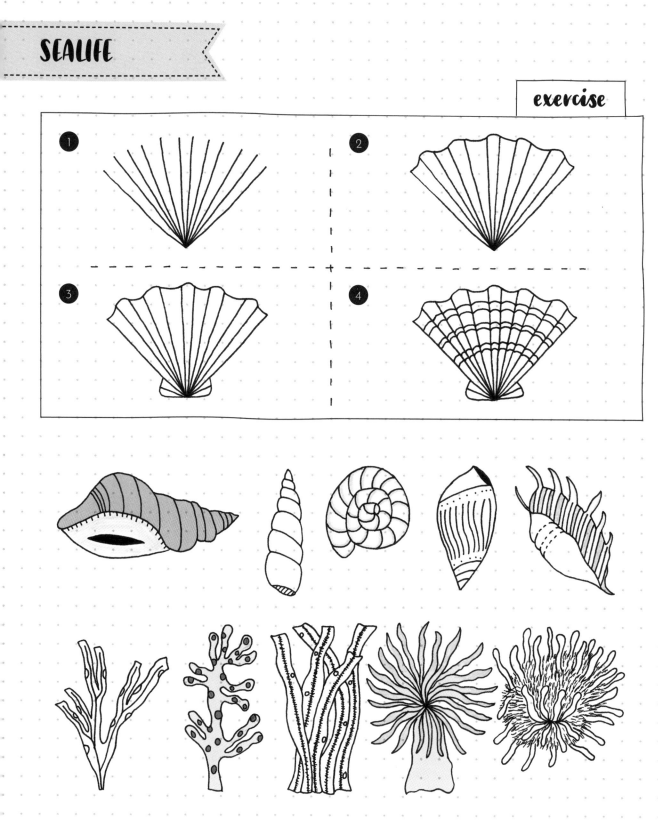

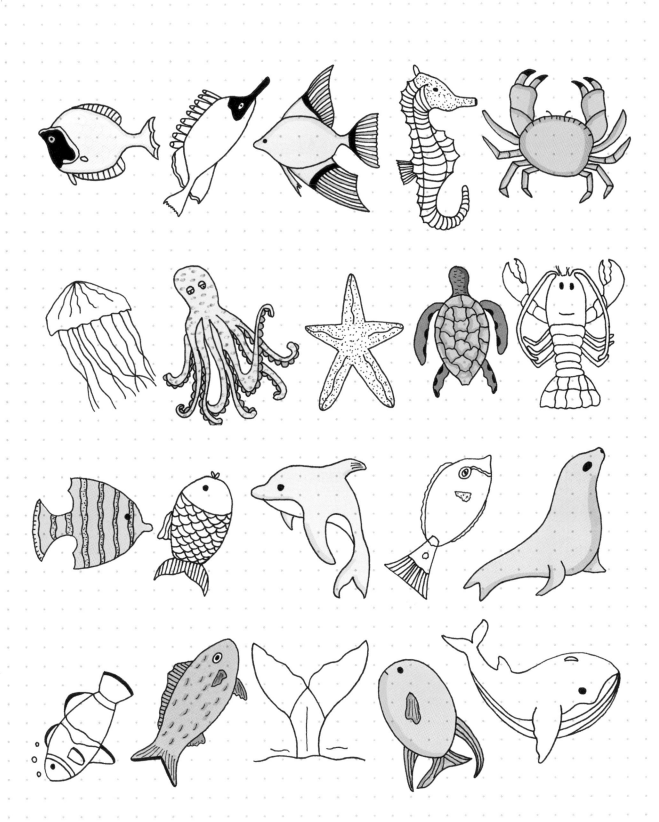

CRYSTALS

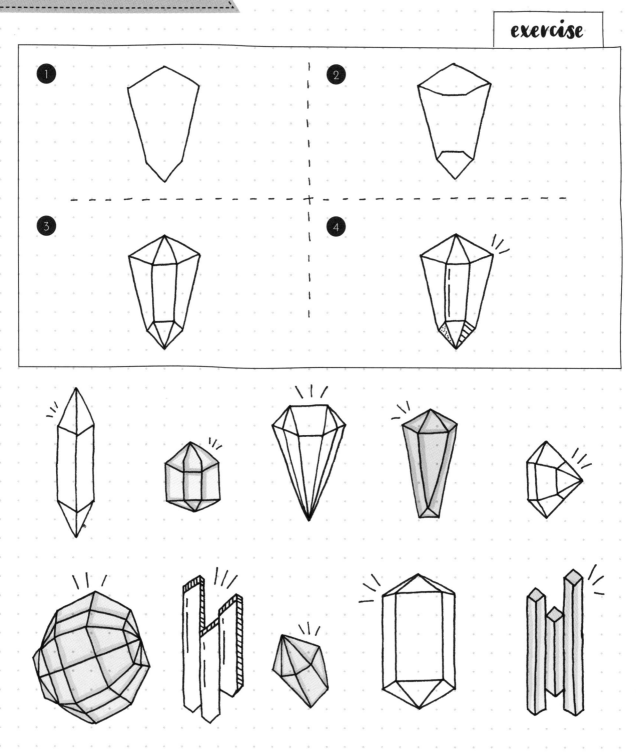

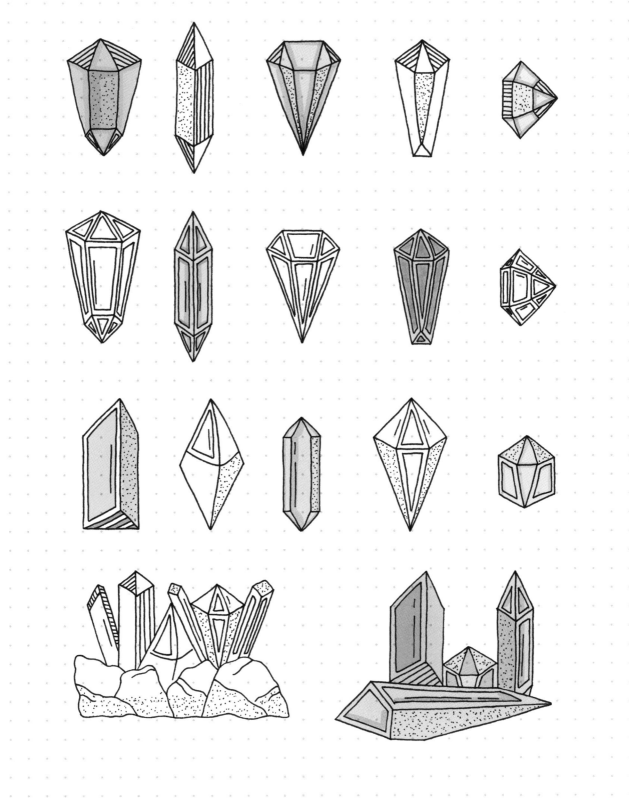

TEEPEES

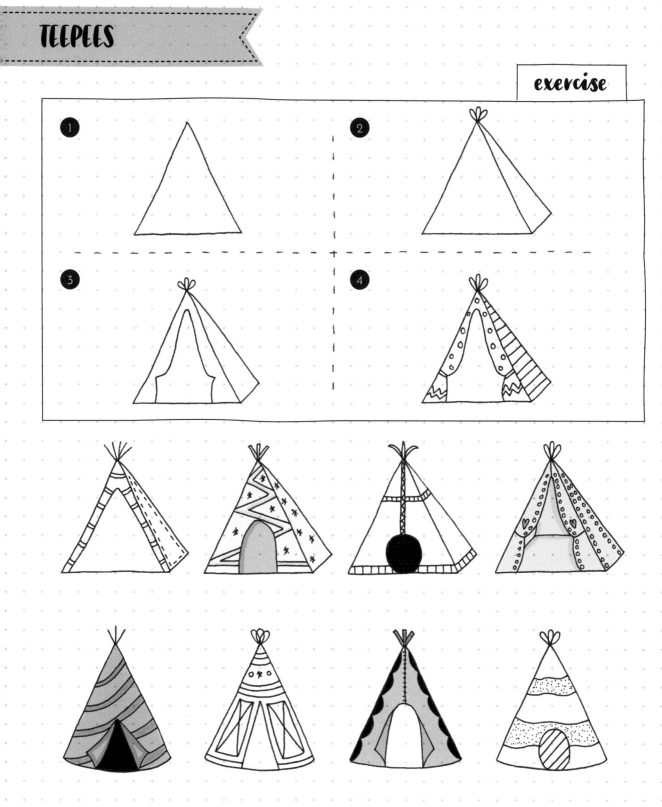

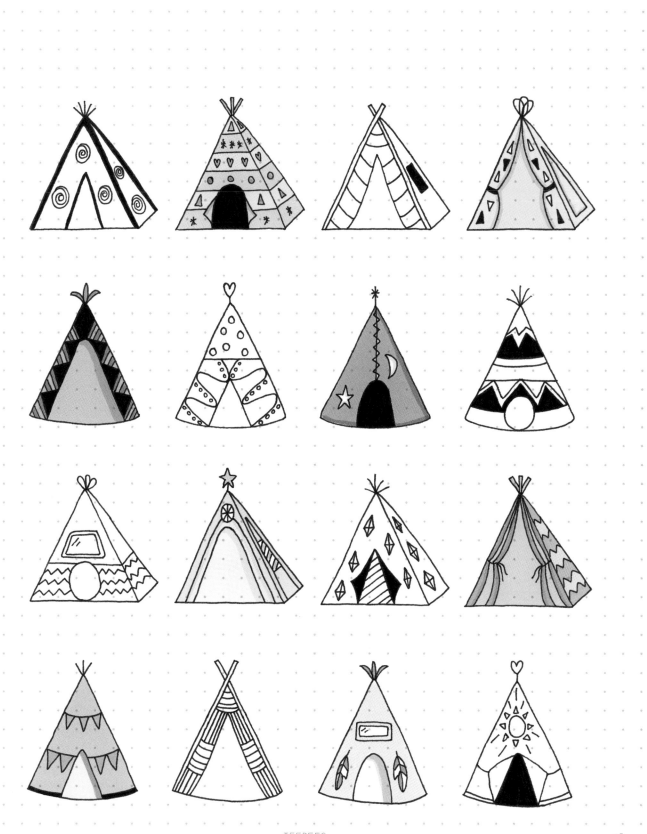

exercise

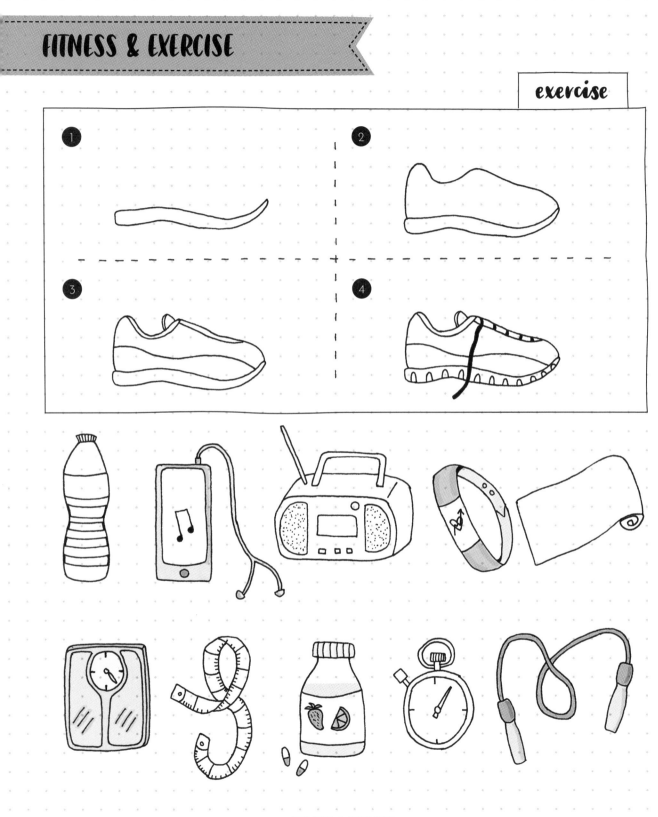

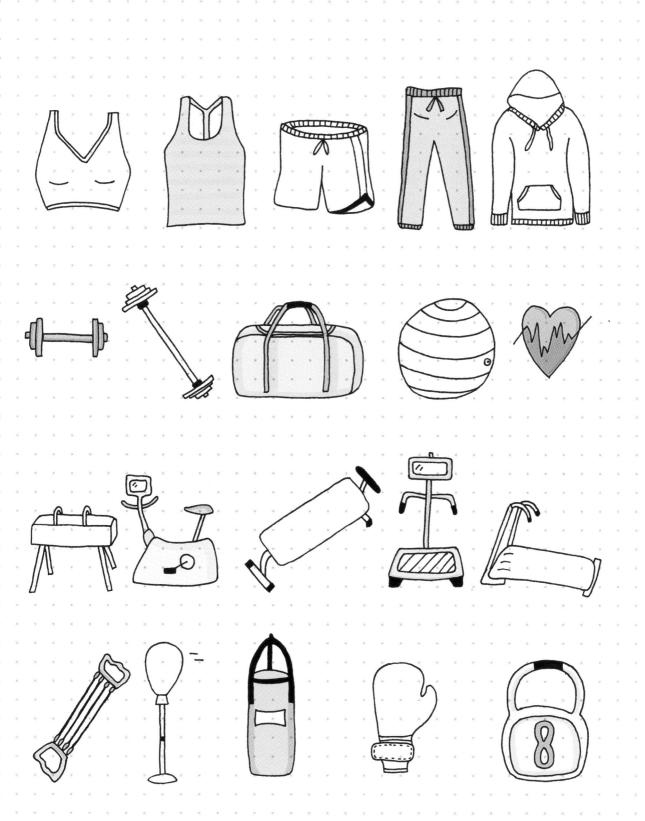

ARTS & CRAFTS

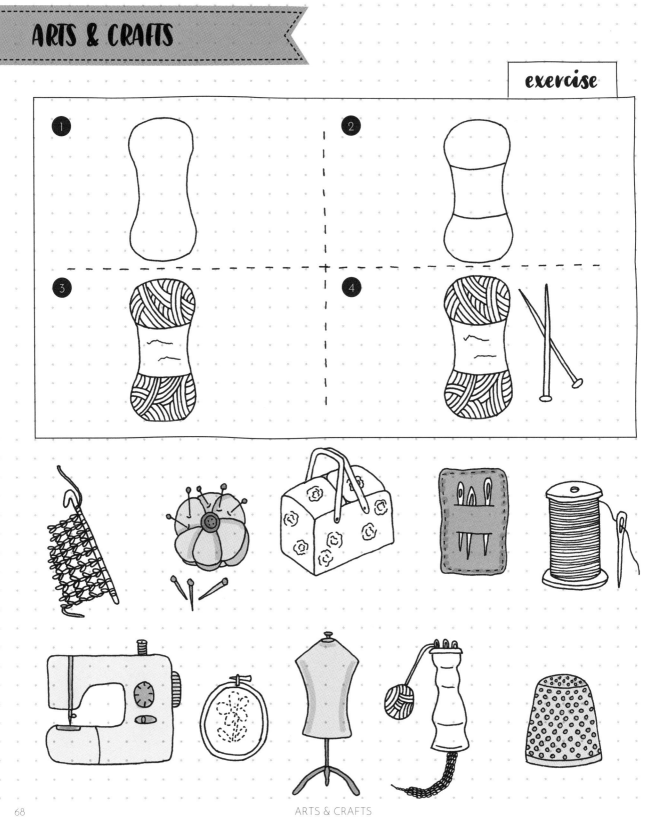

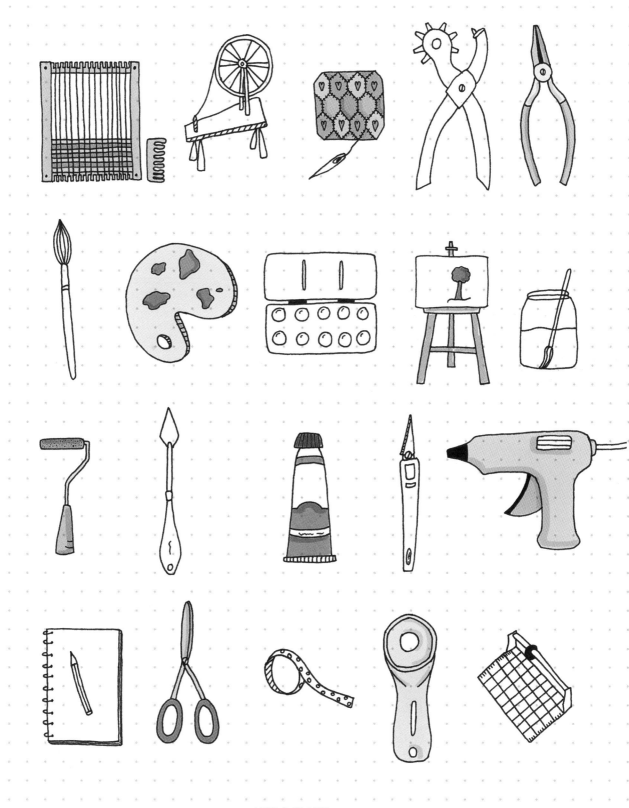

1

2

3

4

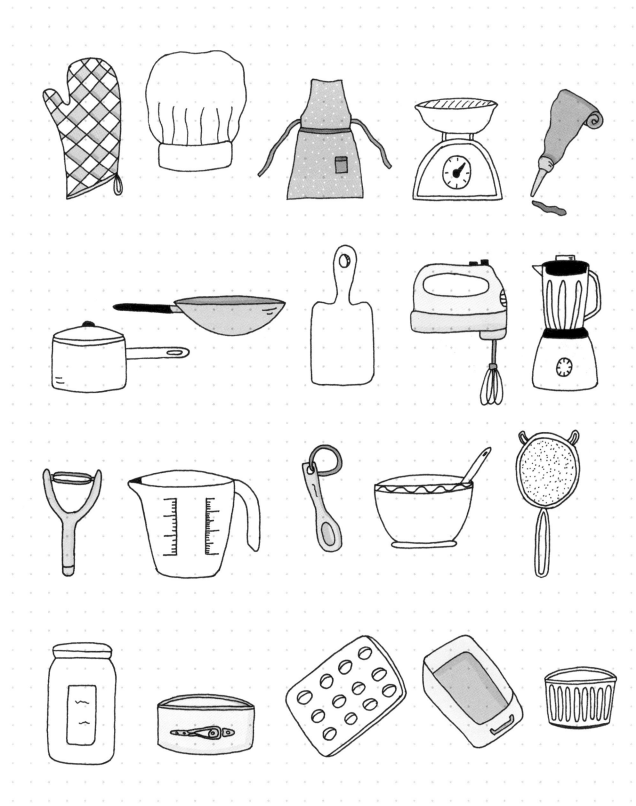

exercise

1

2

3

4

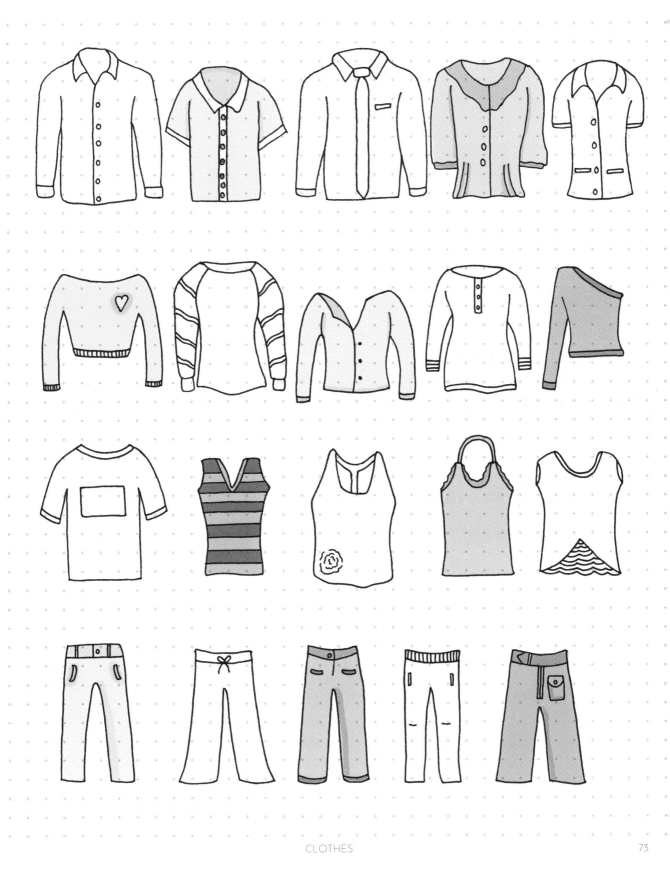

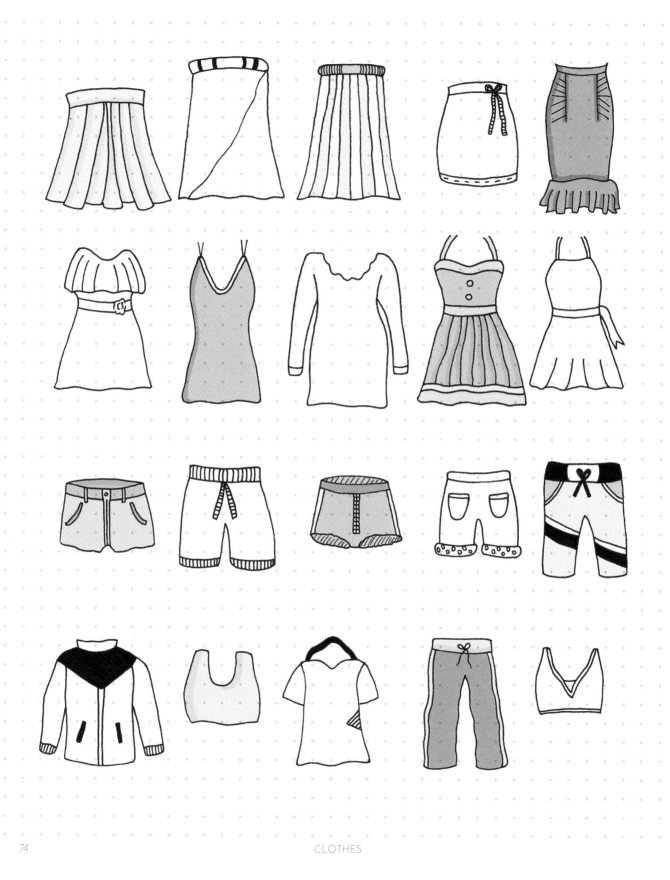

CLOTHES

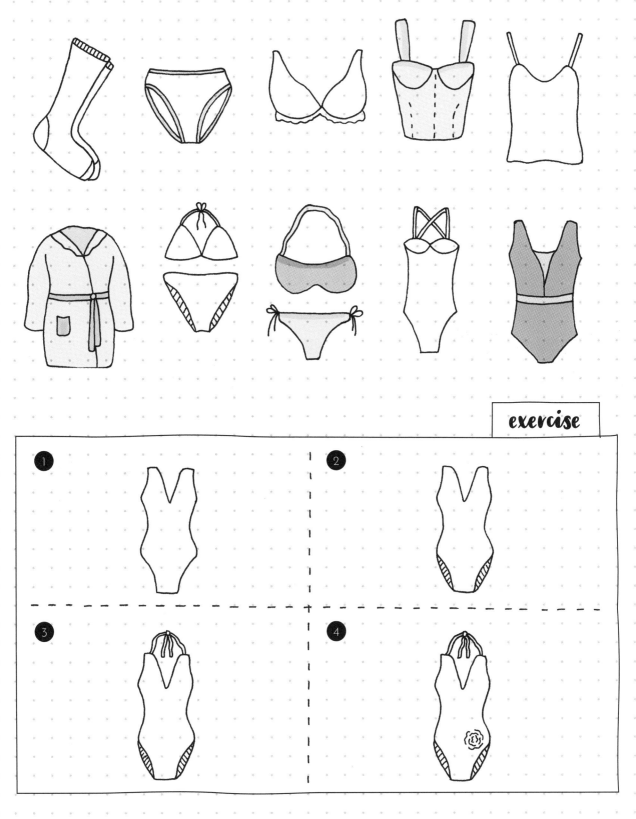

exercise

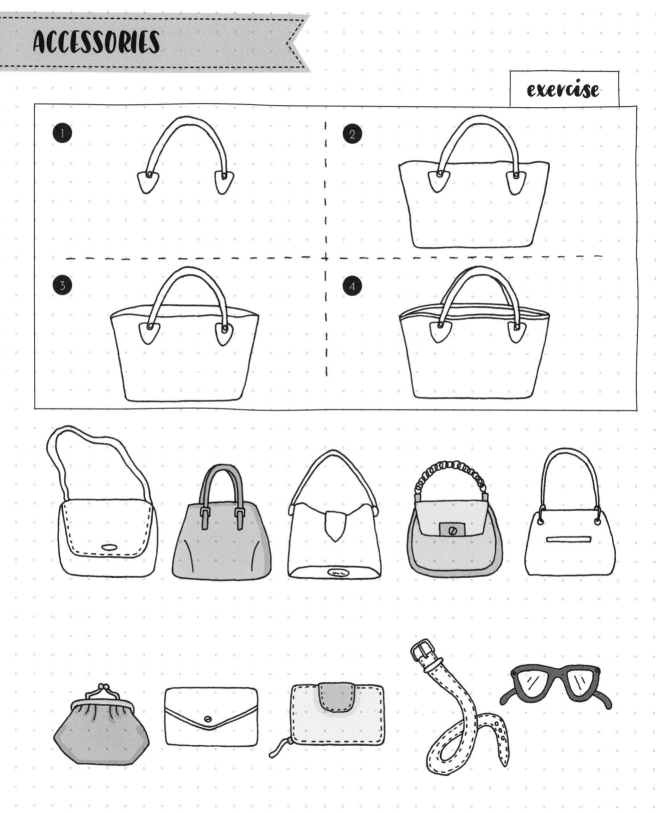

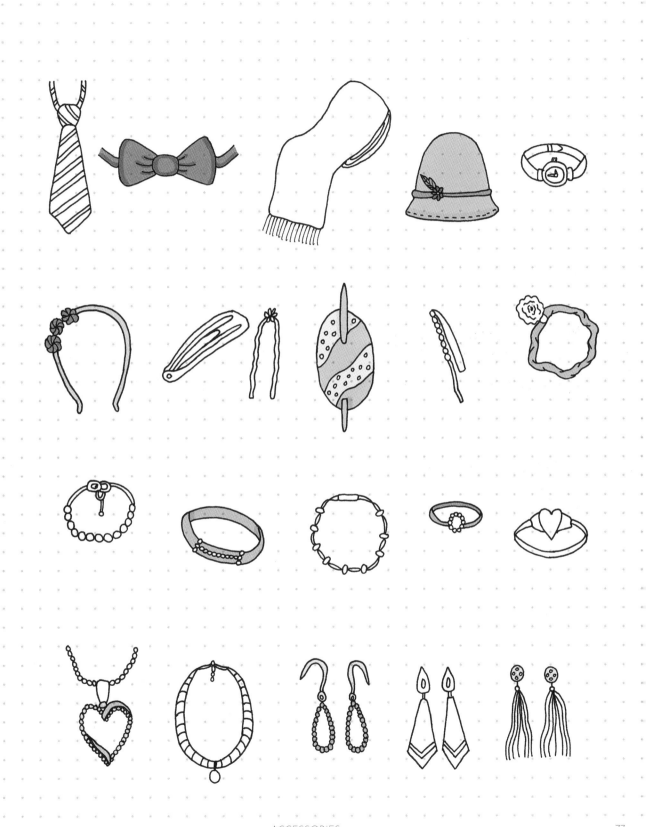

exercise

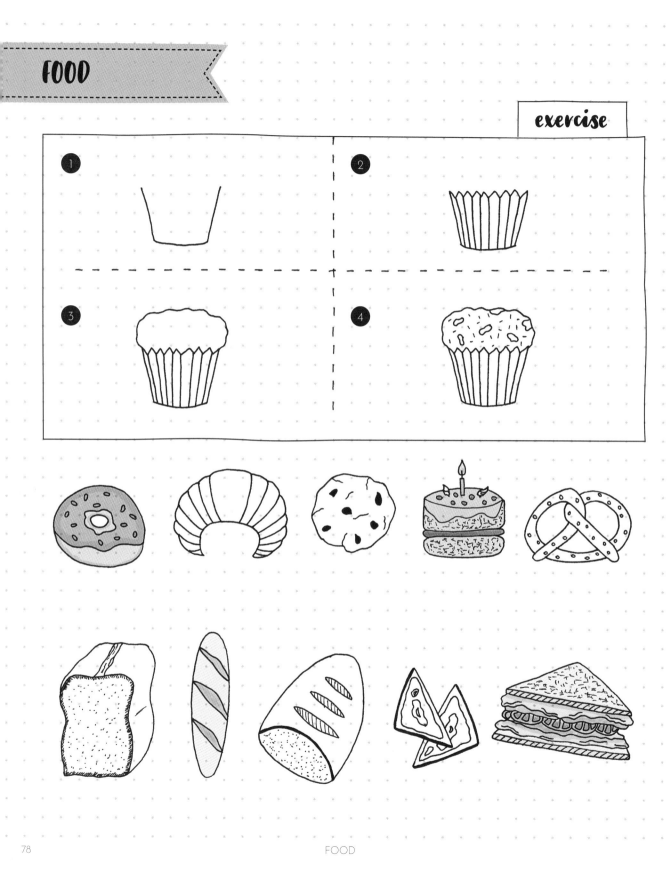

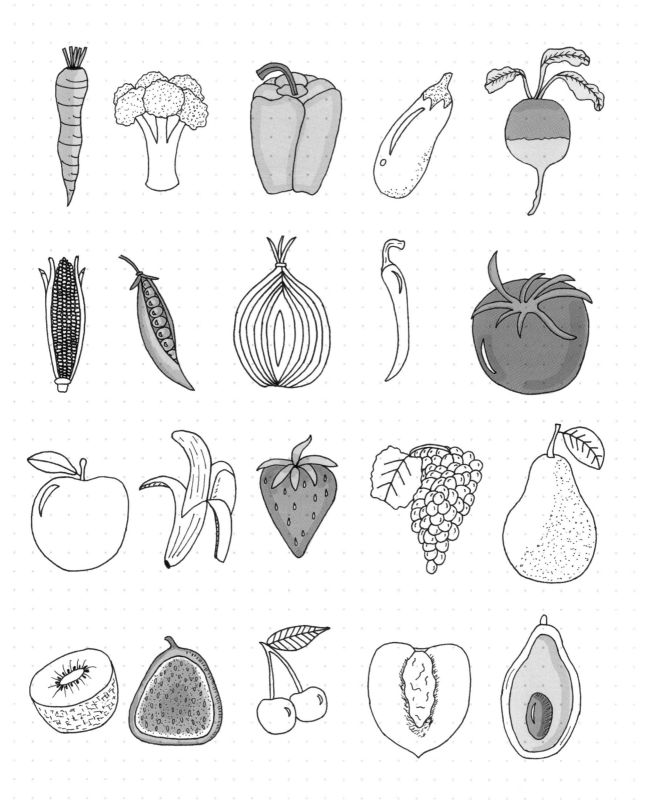

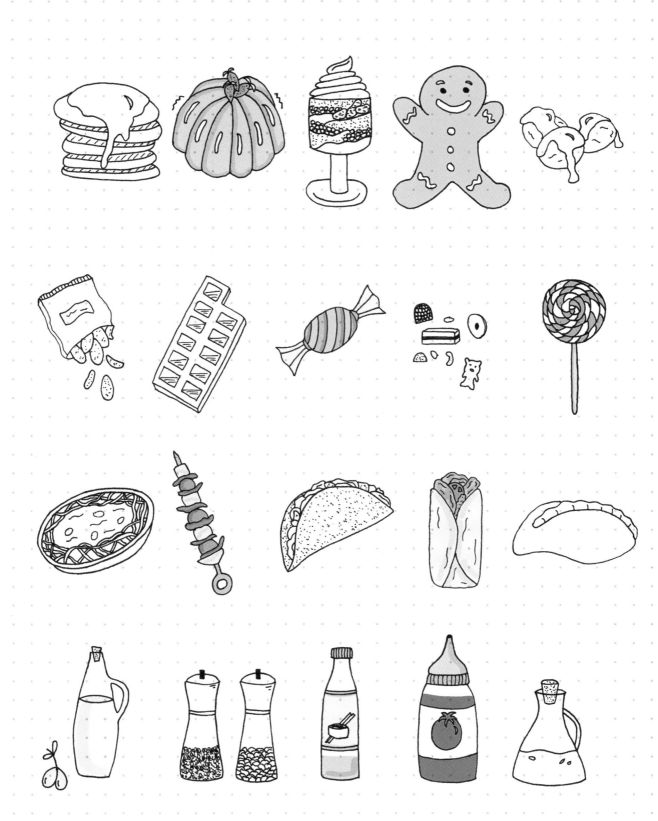

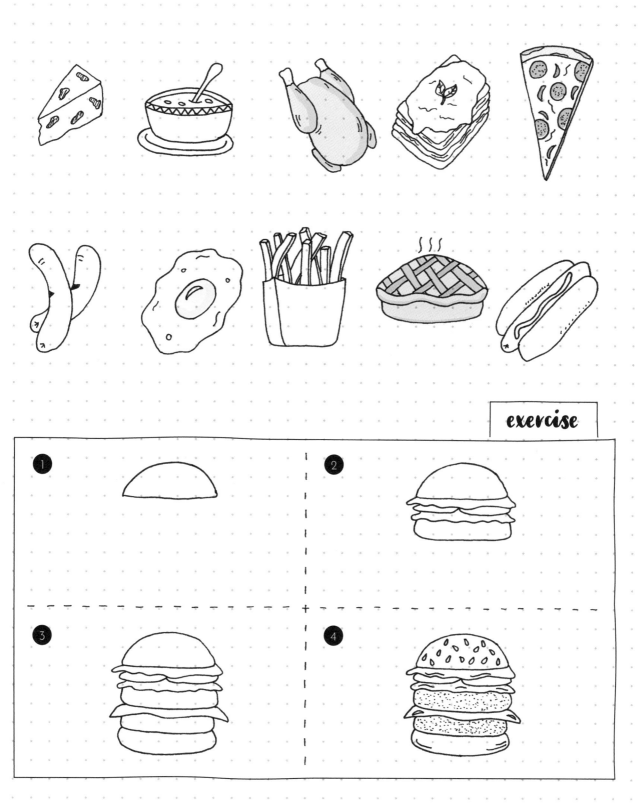

exercise

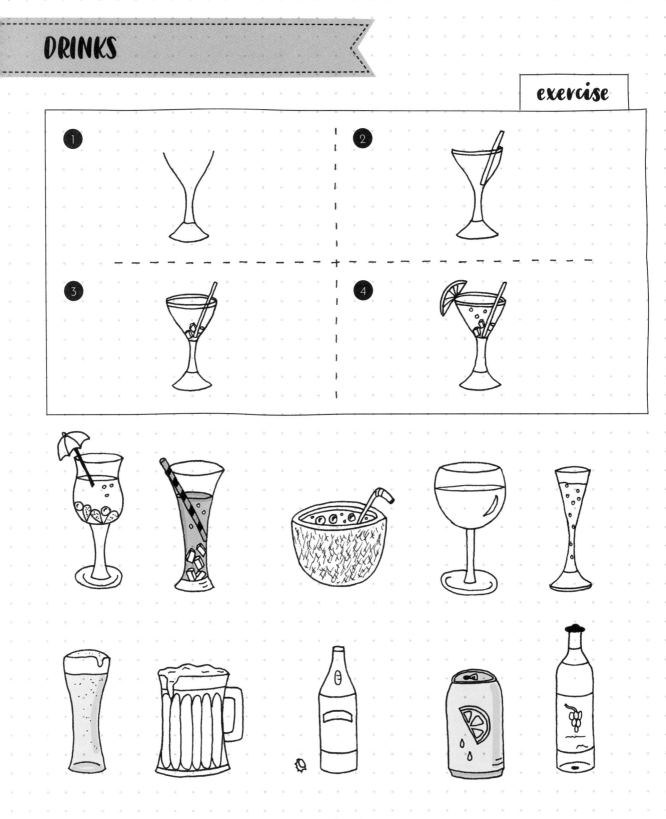

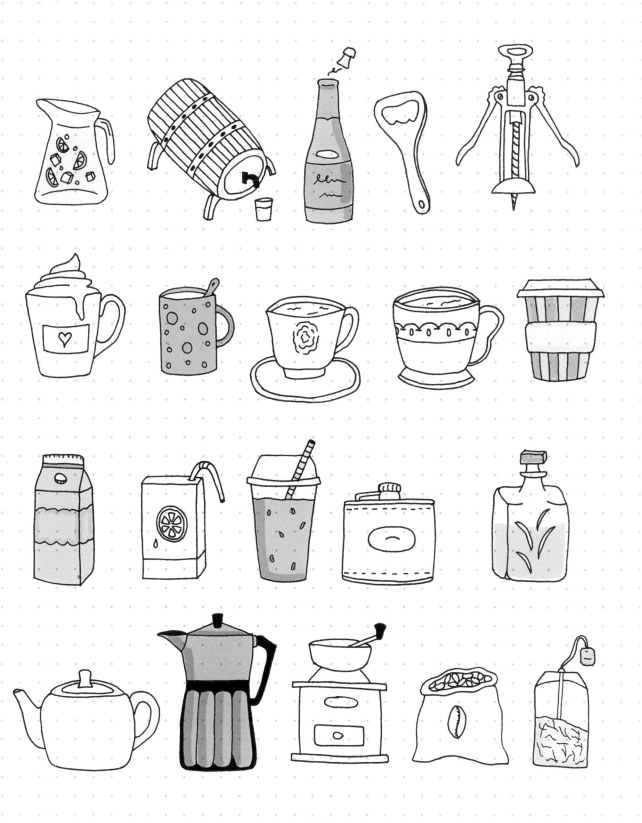

exercise

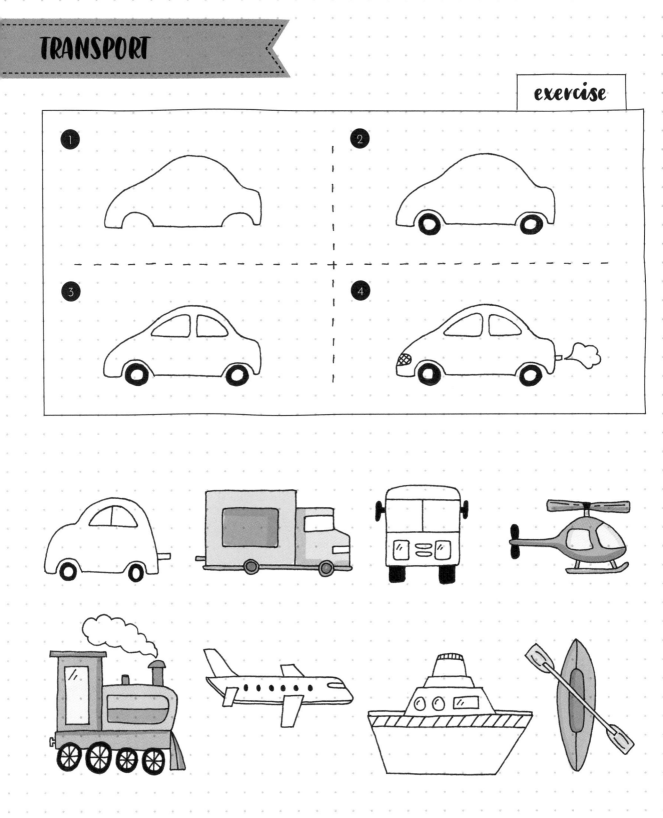

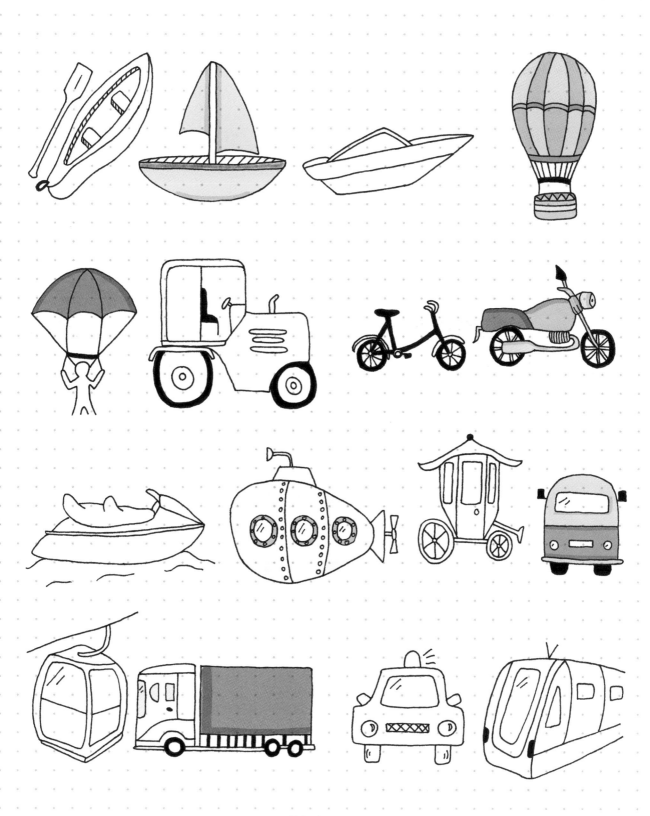

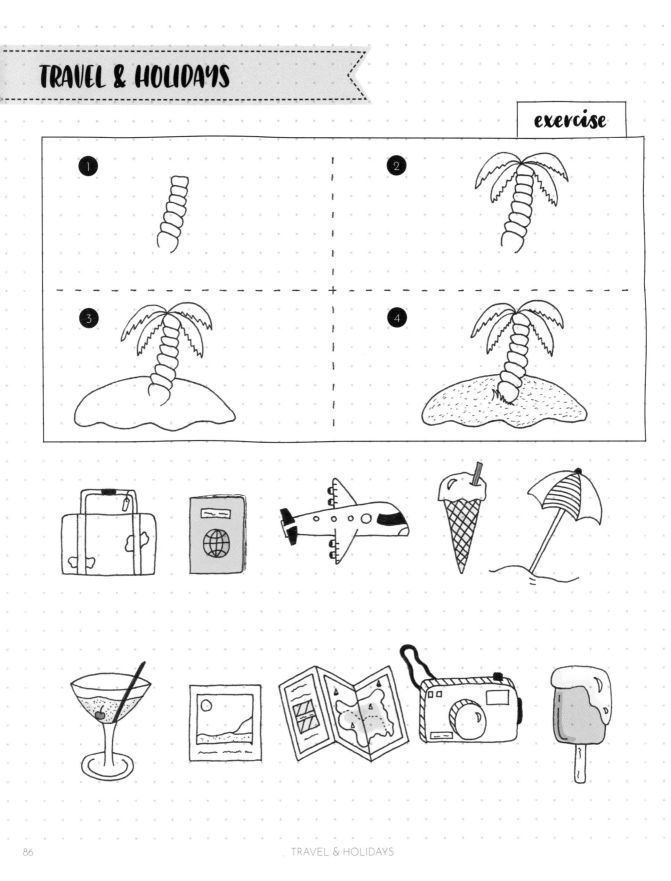

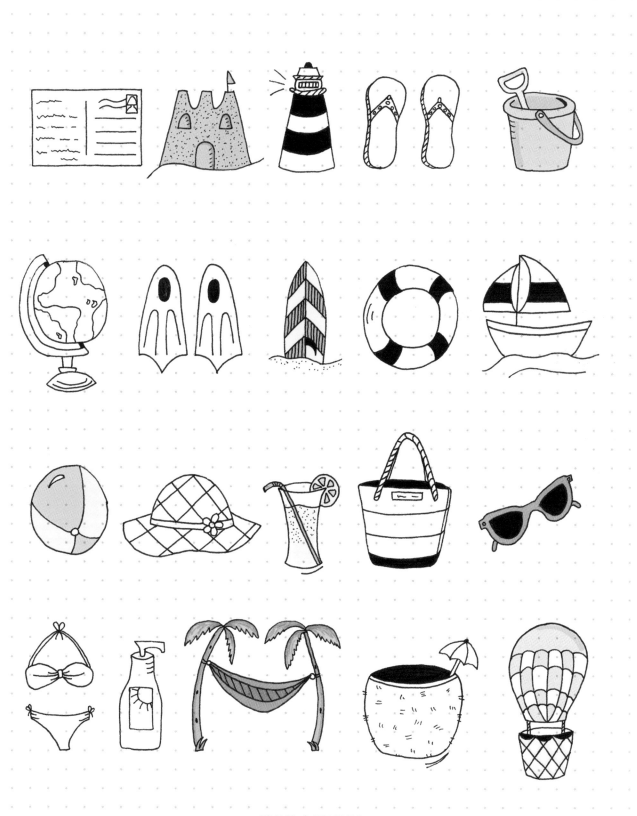

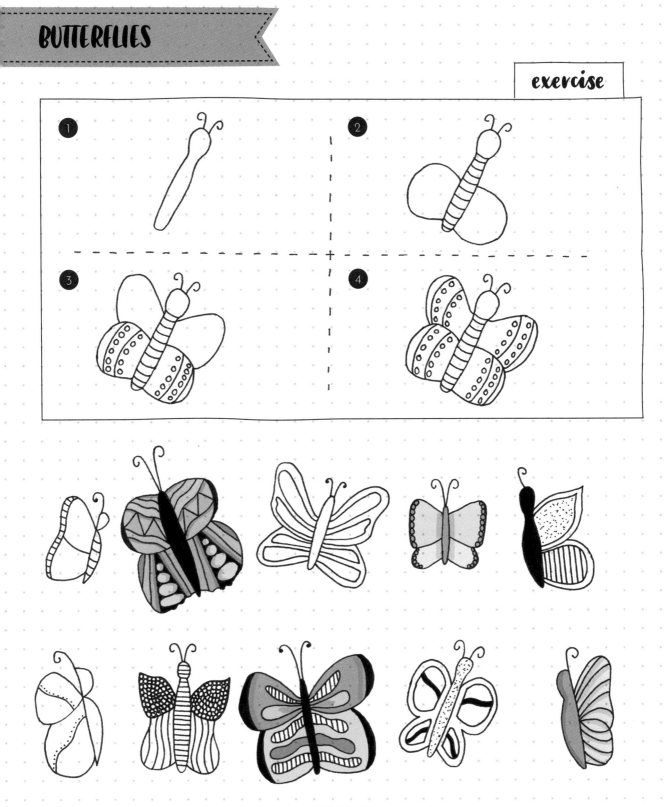

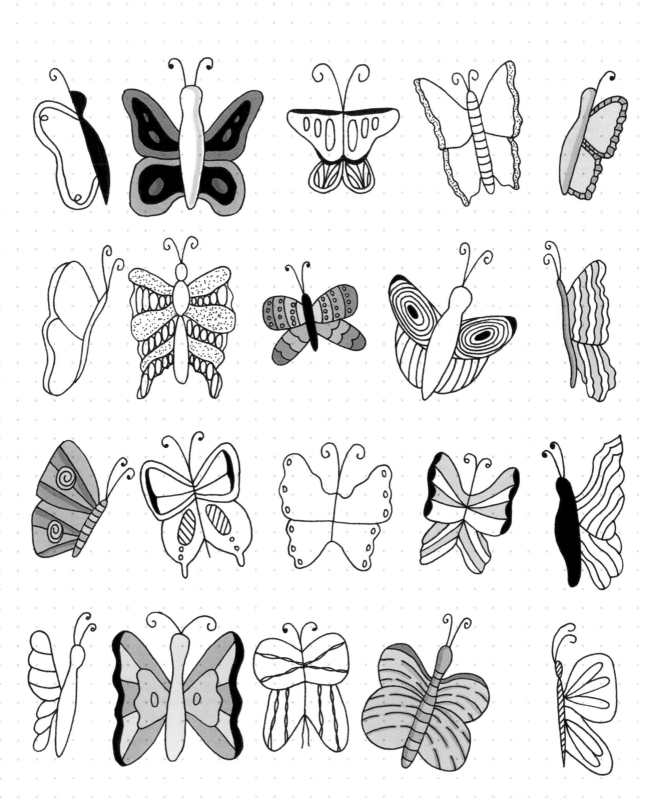

HOUSES

1

2

3

4

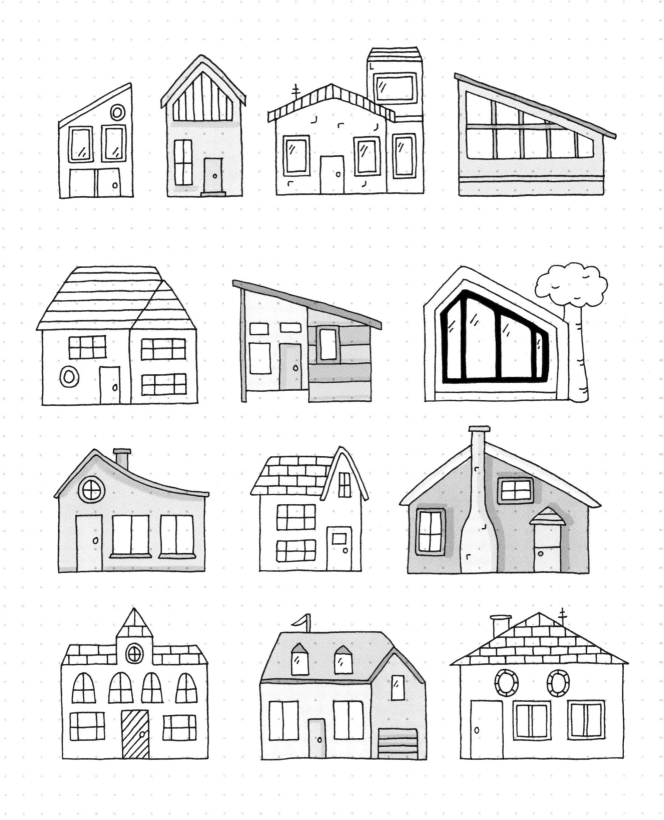

ENTERTAINMENT

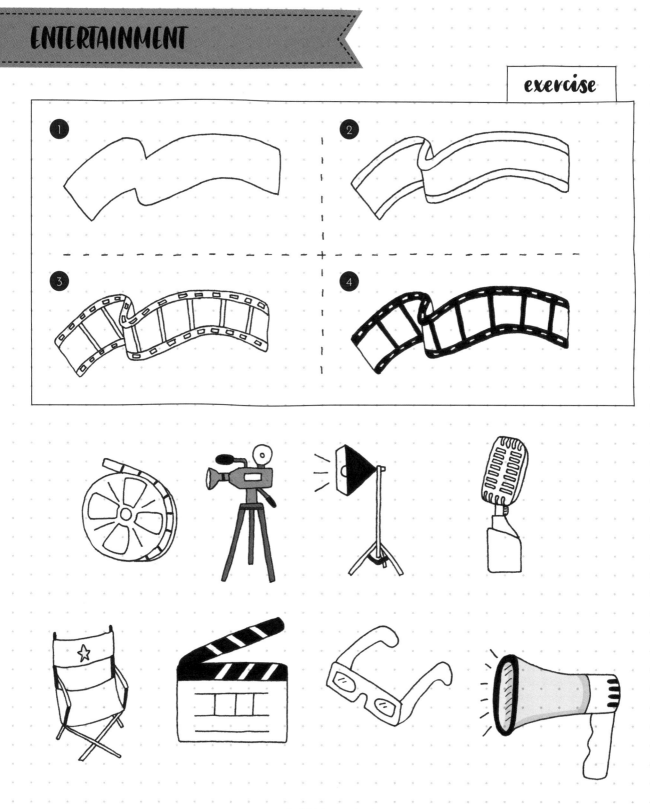

exercise

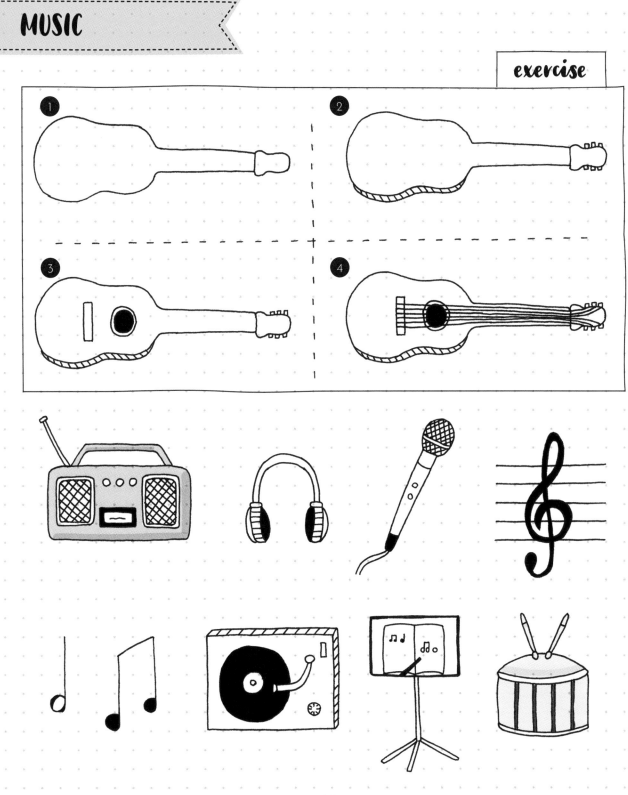

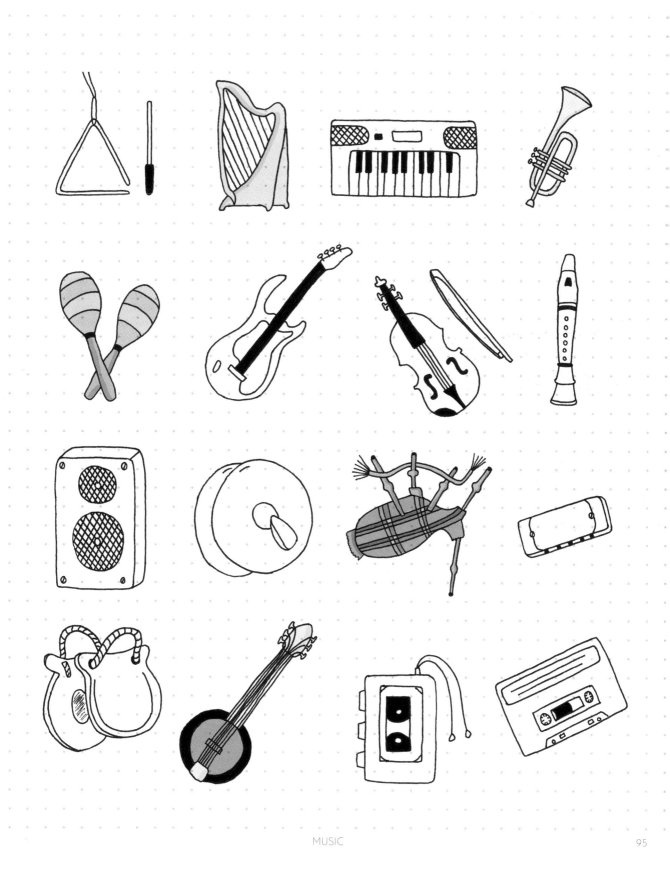

exercise

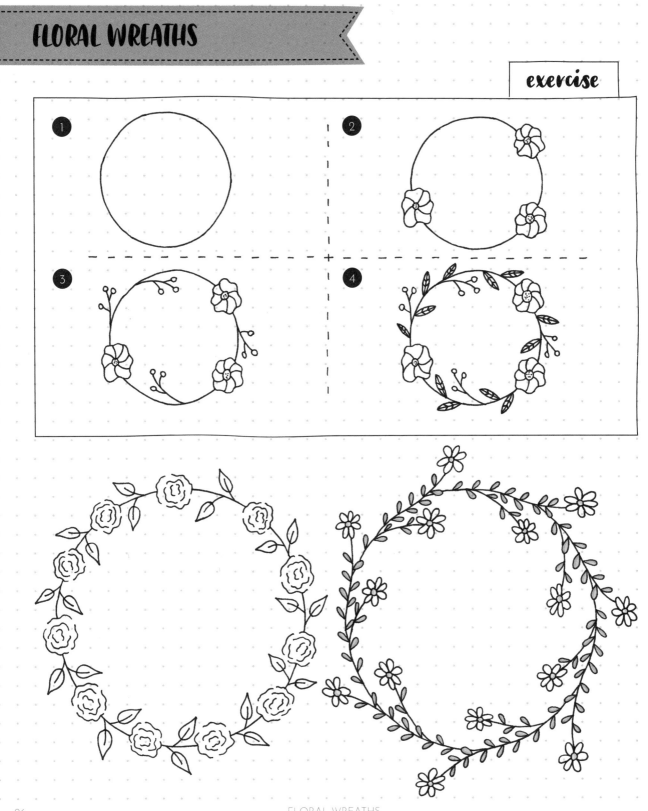

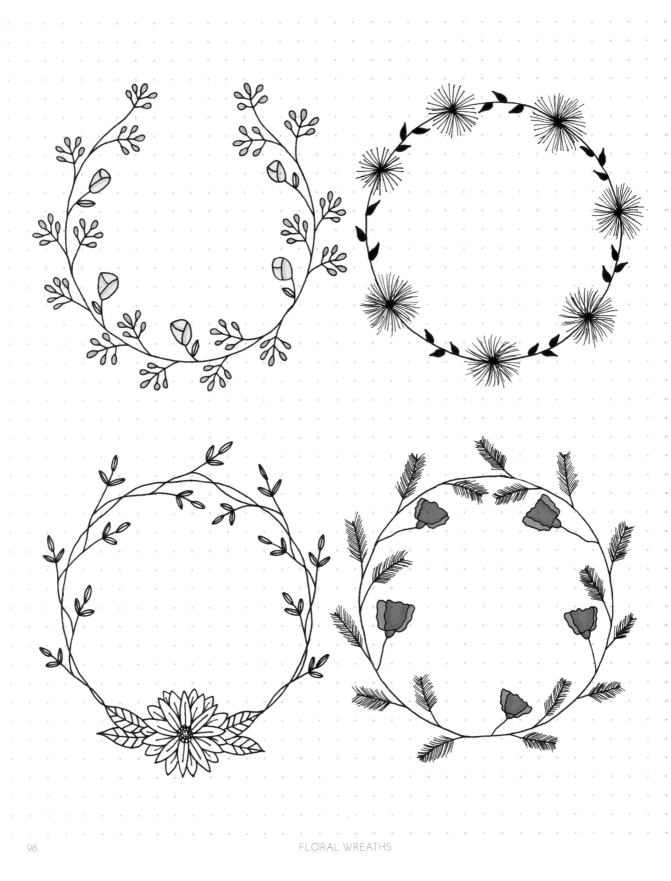

① ② ③ ④

HOMEWARE

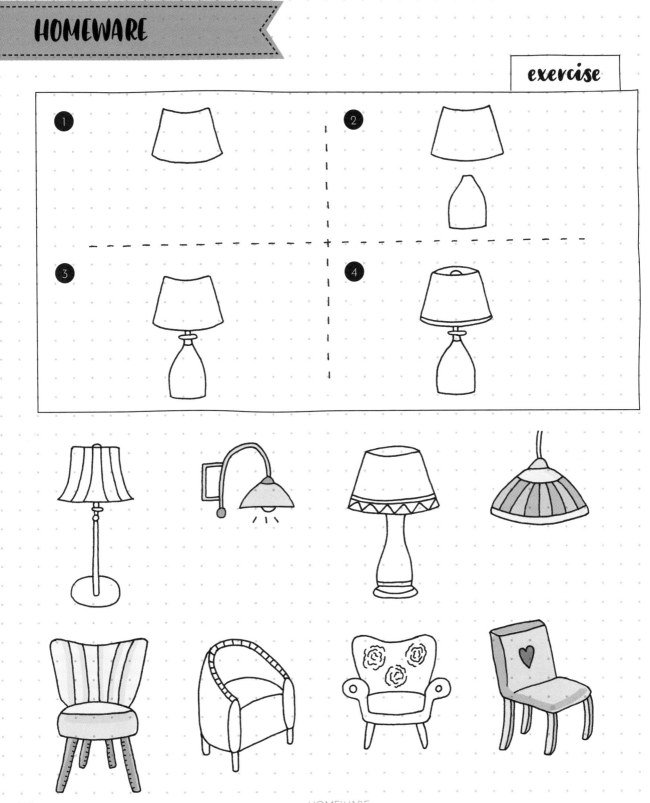

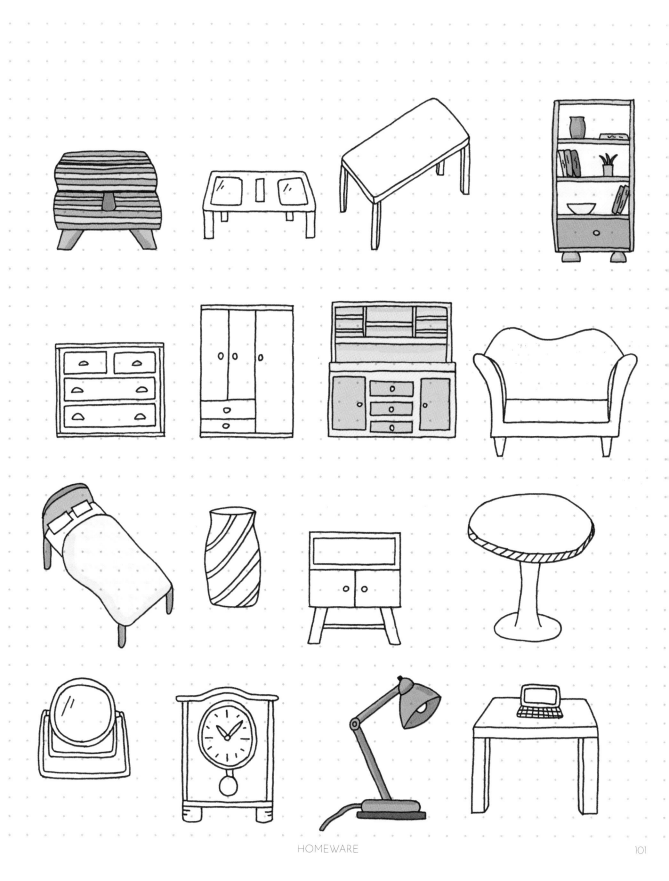

exercise

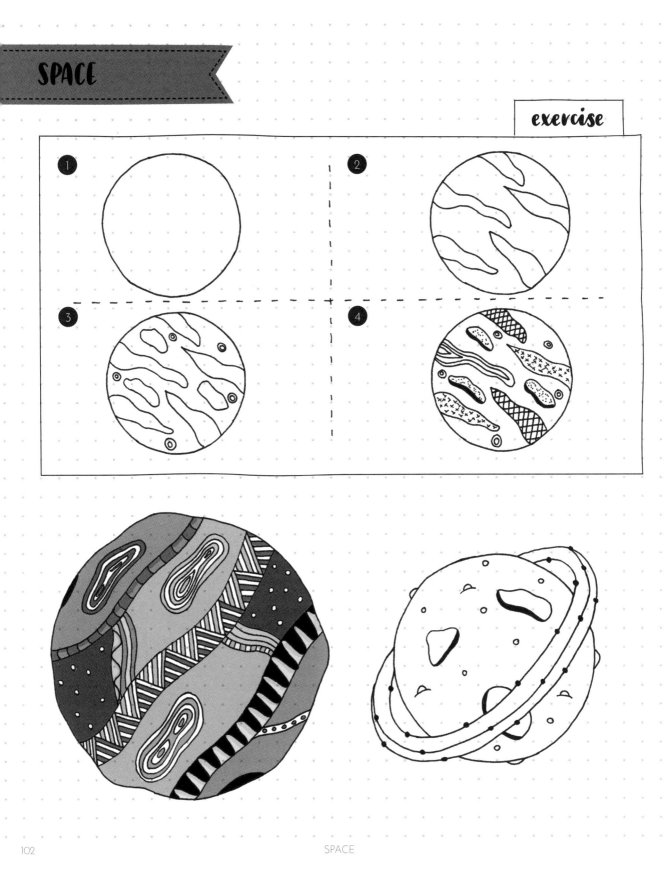

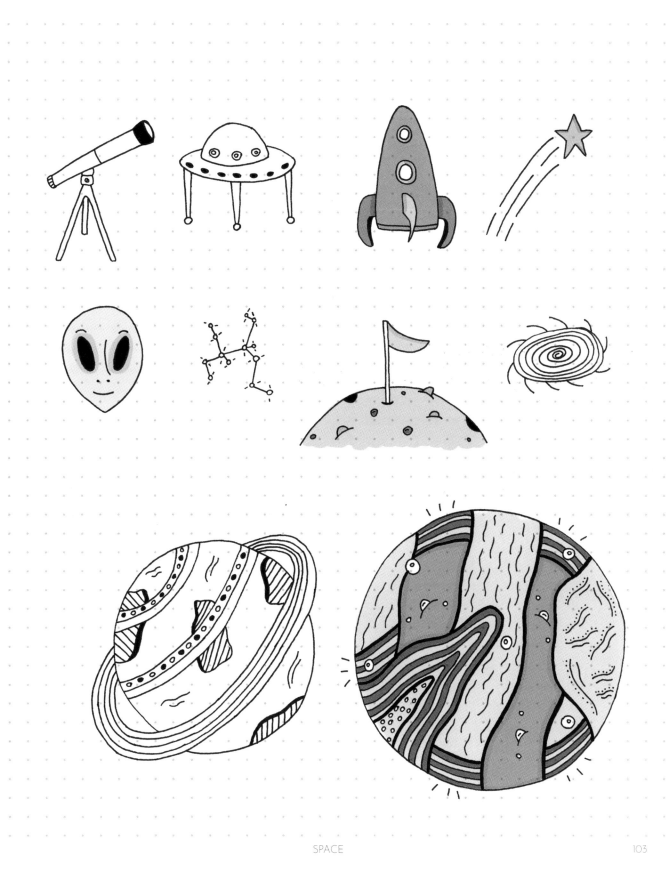

exercise

1

2

3

4

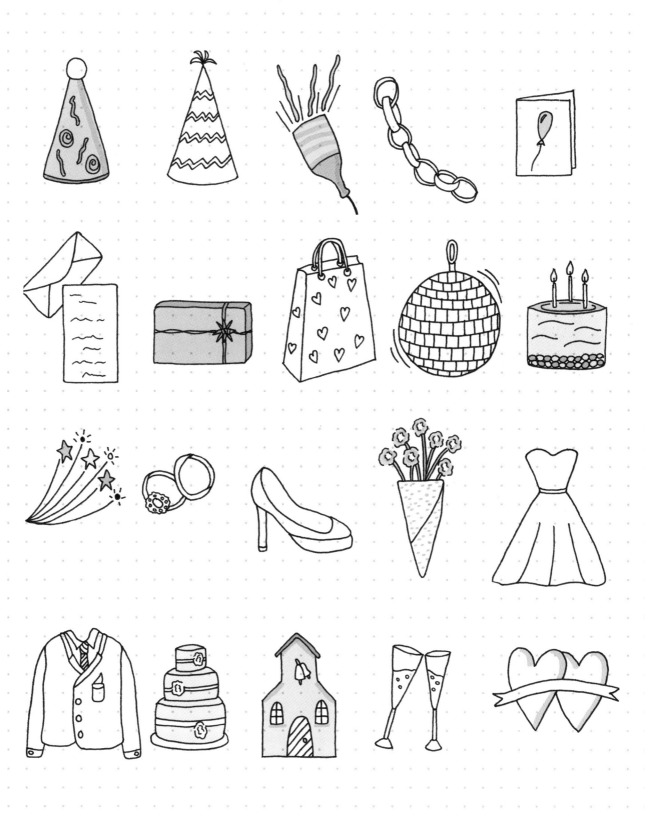

exercise

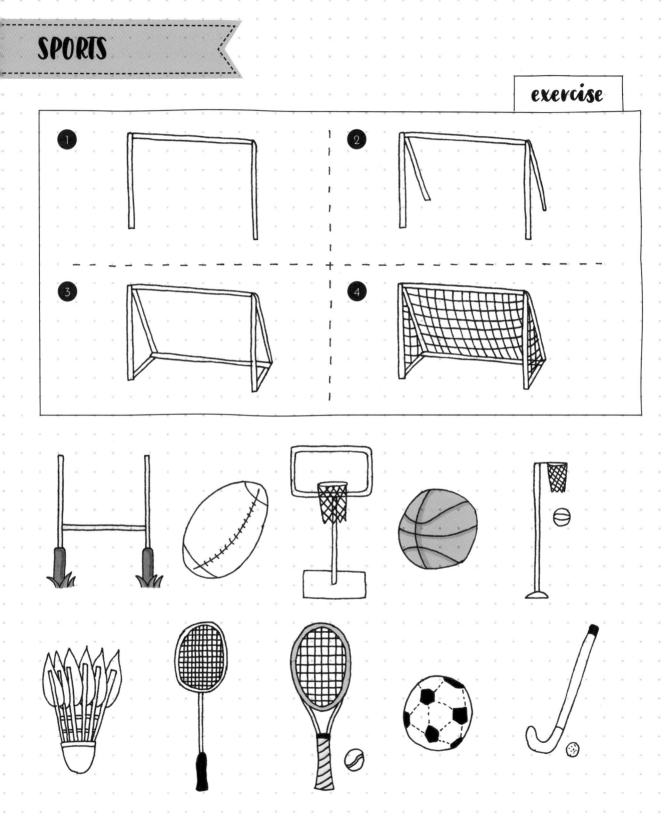

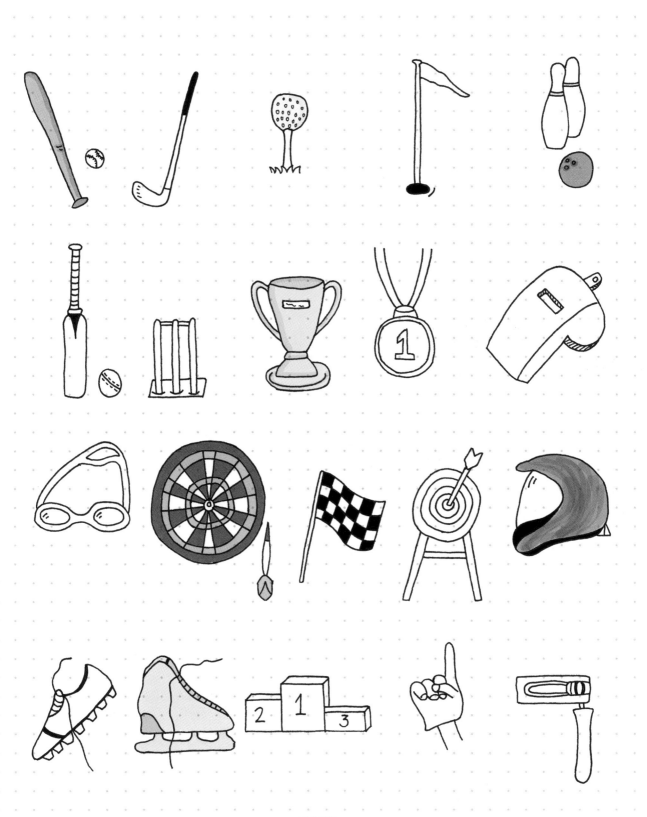

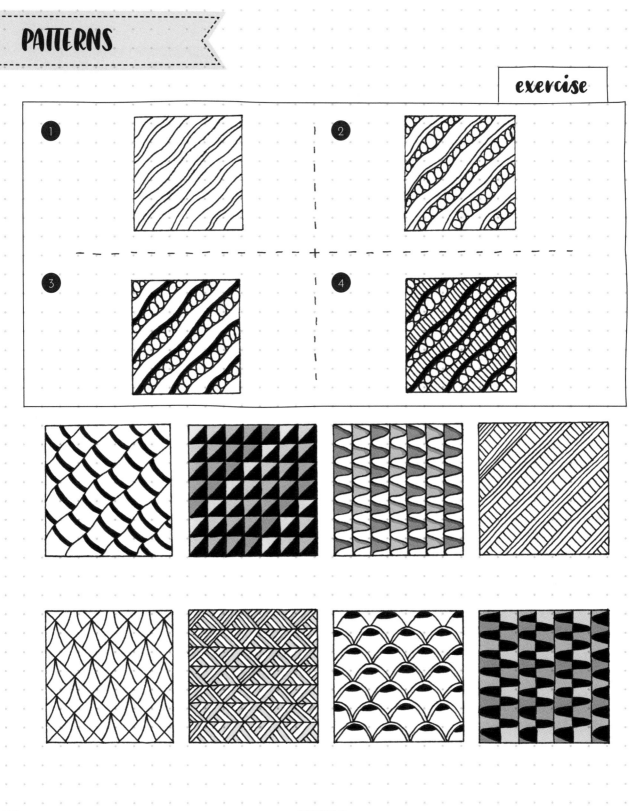

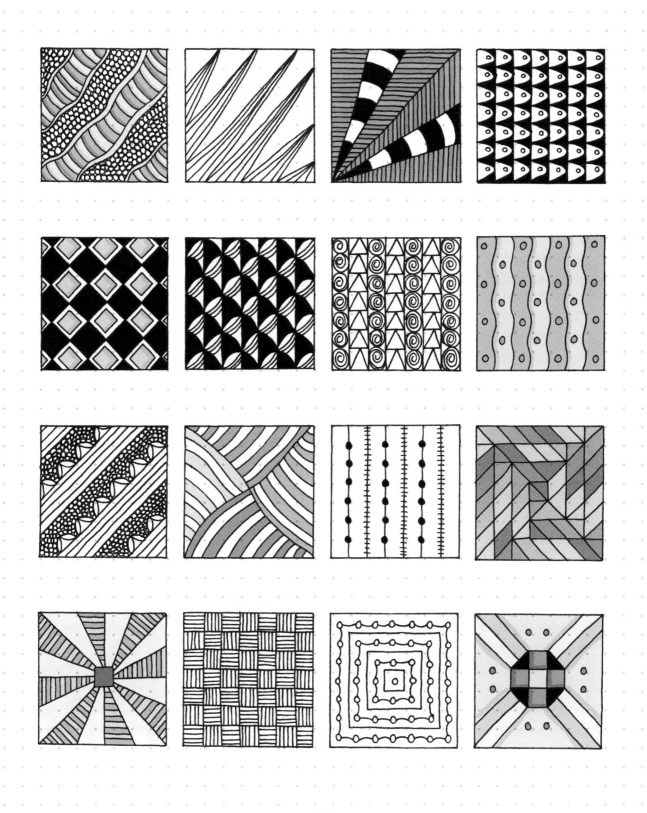

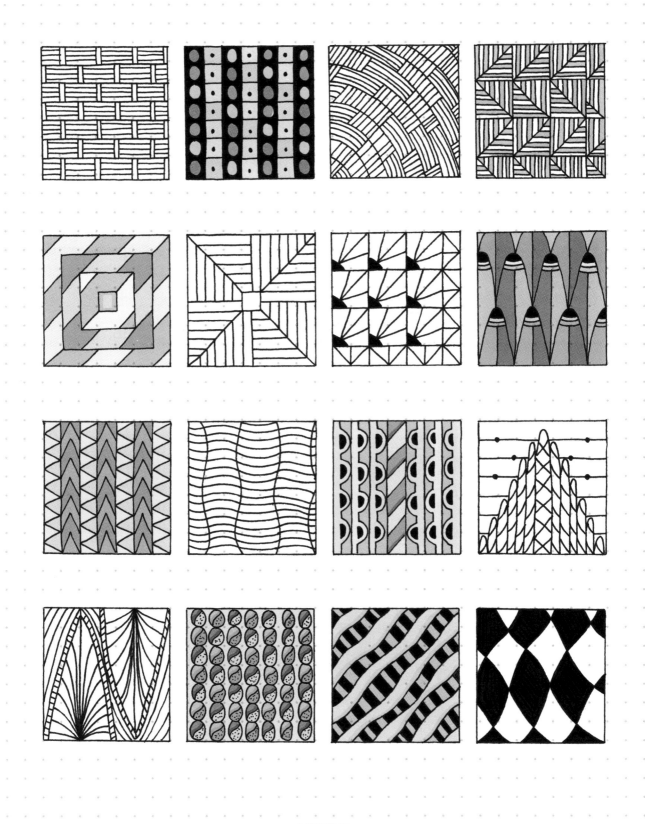

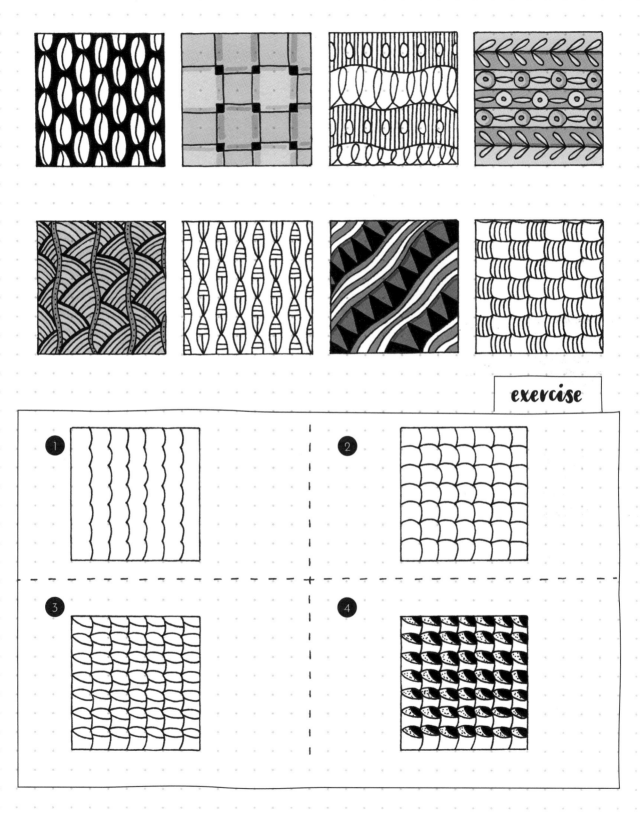

exercise

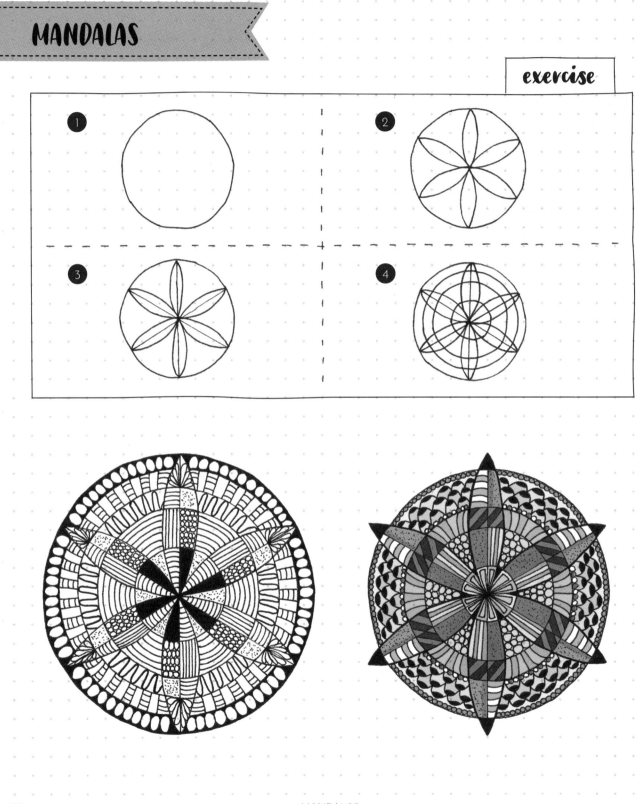

1

2

3

4

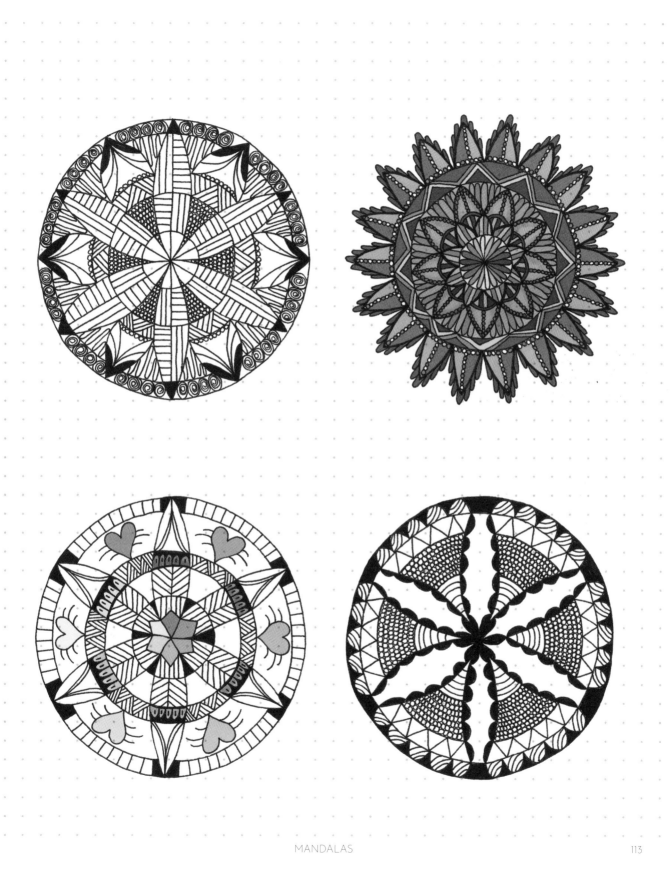

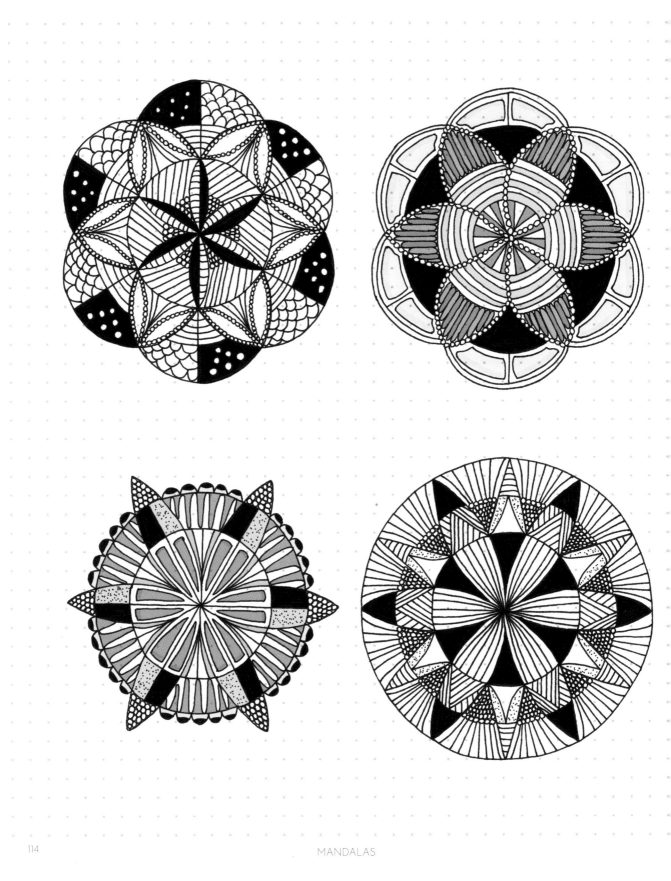

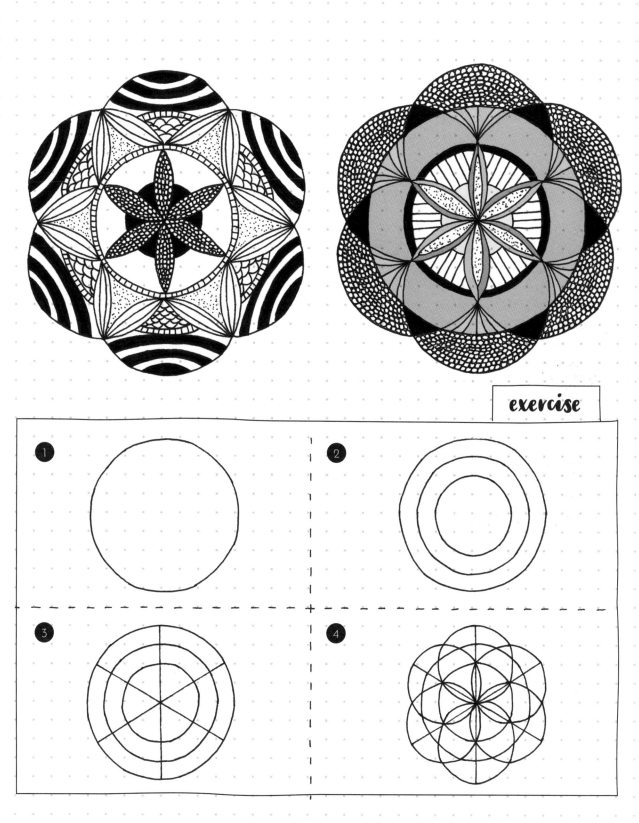

1. *a A*

2. *b B*

3. *g G*

4. *j J*

a b c d e f g h i j k

l m n o p q r s t u v

W X Y Z A B C D E F G

H I J K L M N O P Q R

S T U V W X Y Z 0 1 2

3 4 5 6 7 8 9 ! ' % () & ?

① a → a → a

② f → f → f

③ y → y → y

④ D → D → D

a b c d e f g h i j k

l m n o p q r s t u v

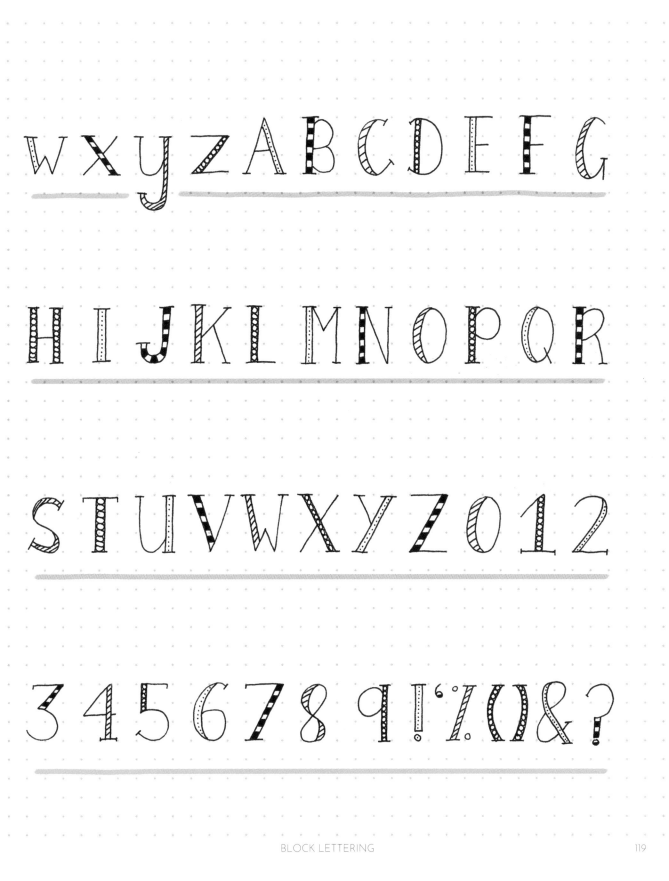

exercise

1. a → a → a

2. f → f → f

3. y → y → y

4. D → D → D

a b c d e f g h i j k

l m n o p q r s t u v

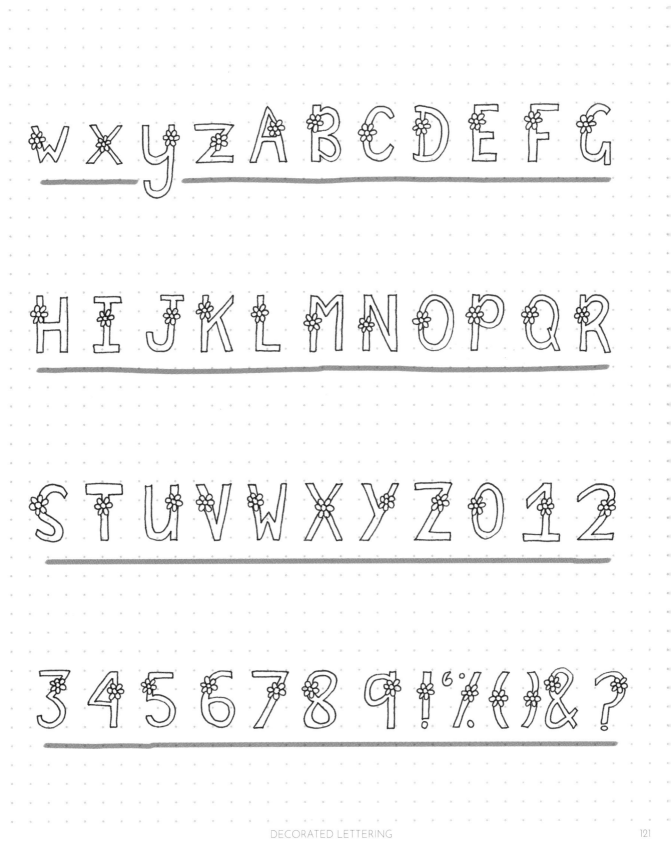

FAUX CALLIGRAPHY

1. a a a
2. b b b
3. g g g
4. j j j

a b c d e f g h i j k

l m n o p q r s t u v

w x y z A B C D E F G

H I J K L M N O P Q R

S T U V W X Y Z 0 1 2

3 4 5 6 7 8 9 ! ' % () & ?

exercise

1. $a \rightarrow a$

2. $h \rightarrow h$

3. $n \rightarrow n$

4. $w \rightarrow w$

a b c d e f g h i j k

l m n o p q r s t u v

W X Y Z A B C D E F G

H I J K L M N O P Q R

S T U V W X Y Z 0 1 2

3 4 5 6 7 8 9 ! " % () & ?

About the Author

Helen didn't think of herself as creative until she found her 'thing' – creative journaling – and began her blog Journal with Purpose (www.journalwithpurpose.co.uk). The freedom and lack of rules made journal-keeping the perfect hobby for her and creativity has now become a very important part of her everyday life.

Helen's journal pages have been featured in various books and she has been interviewed for podcasts and for an article in the *Daily Mail*. In addition, her work has been featured by Cult Pens (part of the WHSmith Group) and was exhibited by Rhodia at The London Stationery Show. She has also collaborated with stationery brands such as Staedtler, Derwent and Manuscript.

Alongside sharing her journals on Instagram, YouTube, Pinterest and her blog, Helen runs journaling workshops online and in person across the UK and is a regular contributor to *Simply Lettering* magazine.

Helen would love to see the journal pages you create using this book, by tagging them on social media using #journalwithpurpose

Suppliers

Stationery Retailers

www.cultpens.com: Online retailer of a huge range of wonderful stationery items, including all of my favourite pens, pencils and notebooks

www.startbaynotebooks.co.uk: My favourite brand of great quality leather notebook covers and journals

www.londongifties.com: A fantastic stationery shop full of unique vintage paper goods, stamps, washi tape and hand-crafted watercolour paints

www.craftstash.co.uk: You can find my own journaling product range here, including stickers, stencils, washi tape and creative papers

Stationery Brands

Rhodia: great quality dot page journals

Staedtler: my favourite pigment liners for writing and sketching, along with a wide range of other great stationery items

Tombow: a lovely range of brush pens

MT: washi tapes

Derwent: my favourite watercolour pencils

Zebra: dual-ended pastel mildliners

TWSBI: Diamond 580AL fountain pen

Index

A DAVID AND CHARLES BOOK
© David and Charles, Ltd 2020

David and Charles is an imprint of David and Charles, Ltd
1 Emperor Way, Exeter Business Park, Exeter, EX1 3QS

Text and Designs © Helen Colebrook 2020
Layout and Photography © David and Charles, Ltd 2020

First published in the UK and USA in 2019

Helen Colebrook has asserted her right to be identified as author of this work in accordance with the
Copyright, Designs and Patents Act, 1988.

The author and publisher have made every effort to ensure that all the instructions in the book are
accurate and safe, and therefore cannot accept liability for any resulting injury, damage or loss to
persons or property, however it may arise.

Names of manufacturers and product ranges are provided for the information of readers, with no
intention to infringe copyright or trademarks.

A catalogue record for this book is available from the British Library.

ISBN-13: 978-1-4463-0747-2 paperback

ISBN-13: 978-1-4463-7872-4 EPUB

Printed in Slovenia by GPS Group for:
David and Charles, Ltd
1 Emperor Way, Exeter Business Park, Exeter, EX1 3QS
10 9 8 7 6 5 4 3

Publishing Director: Ame Verso
Managing Editor: Jeni Hennah
Design Manager: Anna Wade
Designer: Sam Staddon
Photographer: Jason Jenkins
Production Manager: Beverley Richardson

David and Charles publishes high quality books on a wide range of subjects.

For more information visit www.davidandcharles.com

Layout of the digital edition of this book may vary depending on reader hardware and display settings.

Journal with Purpose

Helen Colebrook

DAVID & CHARLES

www.davidandcharles.com

Contents